Tree at my window, window tree,
My sash is lowered when night comes on:
But let there never be curtain drawn
Between you and me.

Robert Frost

1

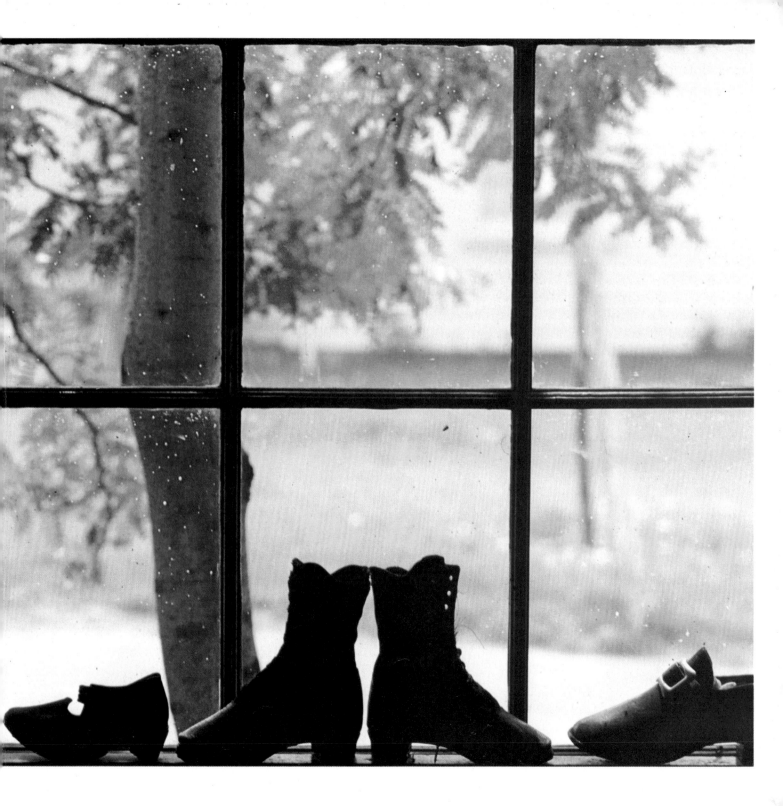

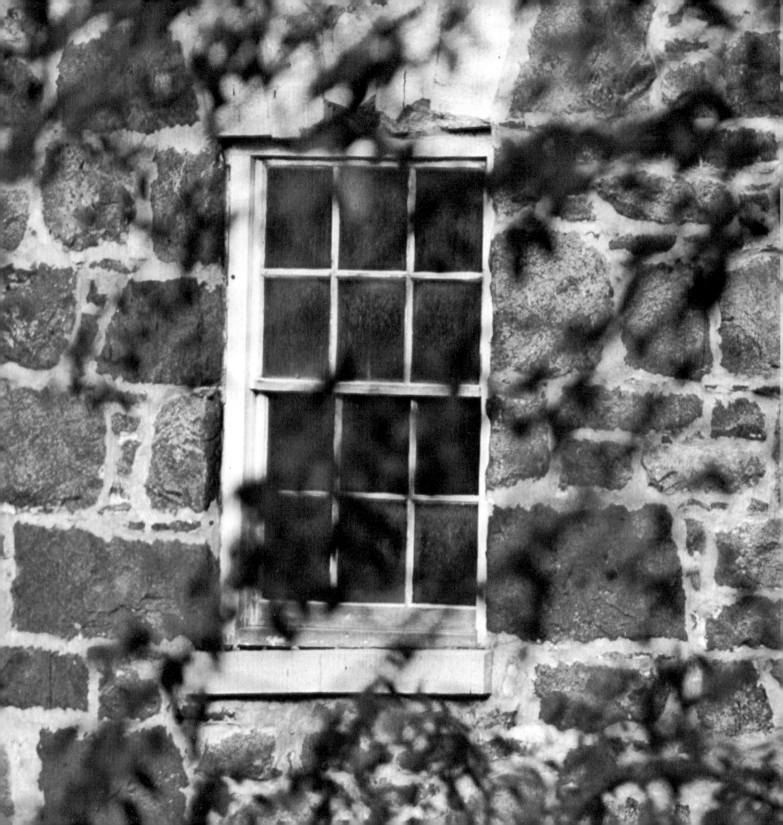

WINDOWS

Text by Val Clery

Photographs by Gordon Beck,
Bill Brooks, John de Visser,
Jennifer Harper, Henry Less,
Bill McLaughlin, Wim Noordhoek,
Peter Paterson, Murray Sumner,
and Richard Vroom

A Jonathan-James Book

PENGUIN BOOKS

Penguin Books Ltd, Harmondsworth,
Middlesex, England
Penguin Books, 625 Madison Avenue,
New York, New York 10022, U.S.A.
Penguin Books Australia Ltd, Ringwood,
Victoria, Australia
Penguin Books Canada Limited, 2801 John Street,
Markham, Ontario, Canada L3R 1B4
Penguin Books (N.Z.) Ltd, 182-190 Wairau Road,
Auckland 10, New Zealand

First published in Canada by Macmillan of Canada 1978
First published in the United States of America in
simultaneous hardcover and paperback edition by
The Viking Press and Penguin Books 1979
First published in Great Britain by Penguin Books 1979

Library of Congress Cataloging in Publication Data

Clery, Val.
 Windows.

1. Photography, Artistic. 2. Windows.
I. Beck, Gordon. II. Title.

TR654.C59 779'.9'7218 78-17082
ISBN 0 14 00.5078 7

Printed in the United States of America by
R.R. Donnelley & Sons Company
Set in Aldus

The credits that appear at the end of this book are
herewith made a part of this copyright page.

Windows

The twentieth century has seen the perfection of techniques that condition the air we breathe and artificially provide the light we need. In fact, some of us spend part of every day in a working world without windows. But could we tolerate those conditions all the time?

There is buried somewhere in our subconscious a memory of times in the earliest reaches of human history when man had to live out his existence in flight and hiding from real or imagined terrors that inhabited an unknown world around him. That memory may occasionally haunt us still in ways we no longer recognize, but against it we may set the present reality of having come to terms with, and having come to understand, that vast unknown world.

Our windows are a real measure of the openness and freedom with which we live now, of our sense of feeling settled and secure. Through them we may watch the growth and decline and return of days and seasons; may observe and be observed by our friends, our neighbors and the passing world; and may appreciate our involvement in life outside, and our individual place in it.

Our windows are our oldest, simplest and most direct medium of communication. We look through them continually, but how often do we look at them? Look at windows! They have more to tell you—about your heritage and about your present self—than they have ever shown you.

The word *window* derives from the Middle English words *windowe* or *windohe* whose origins are in the Old Norse word *vindauga*, meaning "wind eye." How many of the words we have inherited describe with such apt simplicity the purpose of what they define?

The earliest known windows, discovered in the dwellings of a Neolithic village unearthed in Anatolia, were literally wind eyes—small apertures piercing the thick walls of houses, through which people could look out over the community they had created, and through which the fresh air and sunlight could come into their homes.

Those first windows were more than an actual breakthrough, they were a symbolic one. The village itself meant that men had learned at last how to live and work together in peace. The opening up of windows was token of their growing sense of security and of community.

Windows persisted in certain cultures, but it was not until thousands of years later, when the spreading empire of the Romans imposed order and civilization, that windows became a common feature of architecture. The innovation of the stone arch made it possible to have larger openings in walls without weakening support for the roof. A view of the landscape was added to the joys of country life and, to city life, a sense of involvement in the busy activities of the street.

In the wake of the decline and fall of Rome's civilization came the Dark Ages, a pertinent title for those centuries when windows came to be a dangerous indulgence. Men walled themselves in from a barbarous hostile world they did not wish to contemplate, a world in which they wanted as little involvement as possible.

It was not until some order was restored in the late Middle Ages that windows began to re-appear. At first in churches, to grace and illuminate the art and grandeur dedicated to God, then in feudal courts to highlight the secure power of the ruler, and finally, gradually, in homes as token of the assured prosperity of merchants and craftsmen and of the slow emancipation of the common people.

Although war and disorder have returned to haunt our world many times in the intervening centuries, we have managed each time to pull back from the fearsome oblivion of another Dark Age. We have kept our windows—even if at times they have been shattered. For all our prevailing uncertainties, windows predominate over walls in much of what we build today. Surely that must signify, if nothing else, a persistence of hope?

In basic form, windows have altered very little through uncounted centuries. We can still come across mere openings in walls as crude as those first wind eyes of the Neolithic settlement. The window framed by the Roman arch of stone or brick has been improved on very little. Its inherent problem, an inability to withstand the combined weights of a high wall above it and of the roof, meant that in the earlier churches of the Middle Ages the windows, often unglazed,

3

had to be set high in the walls. Medieval craftsmen solved the problem by building roof-supporting buttresses into the walls, allowing the intervening expanses of wall to be opened up. Those vast stained-glass windows, which are among the greatest glories of religious architecture, were the result.

Glazing—the means of letting light in through windows while keeping weather out—has a history as old and as fascinating as that of windows. The first form of glazing was probably fine-woven cloth, oiled to make it translucent. Al-

though the means of making glass had been discovered long before the Roman era, it was difficult to make thin clear sheets of it. The Romans, when they glazed windows, usually did so with sheets of crystalline gypsum. Methods of moulding or rolling out sheets of glass were improved, but only gradually. Even in the Middle Ages, when windows could be made much larger, it was still not possible to produce large sheets of glass. The solution was the leaded window—small panes of glass, called *quarrels* (the Latin for a small square) set in strips of lead called *cames*.

Because of the fragility of leaded glass panes, they had to be braced by vertical and horizontal stays of wood or stone, dividing them into sections called *lights*. But although sheet glass long ago superceded leaded glass in all but church windows, the names originally given the stays have persisted until quite recently: the upright stays were called *mullions* or *munnions*, probably from the Old French word *moignon*, meaning the stump of a tree or the pinion of a wing feather; the cross stay was called a *transom*, from the Latin *transtrum*, the cross stay of a boat.

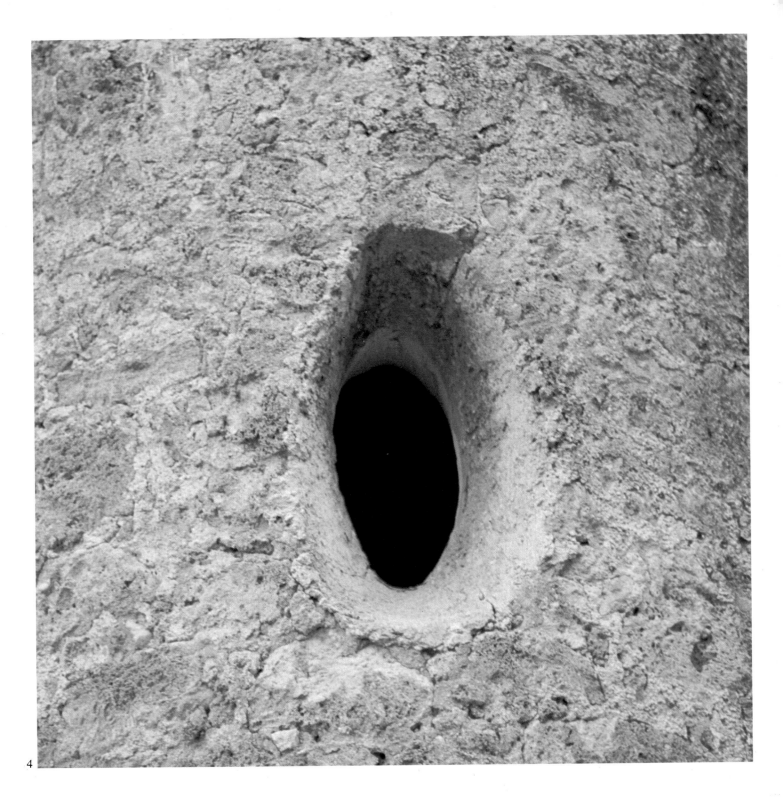

4

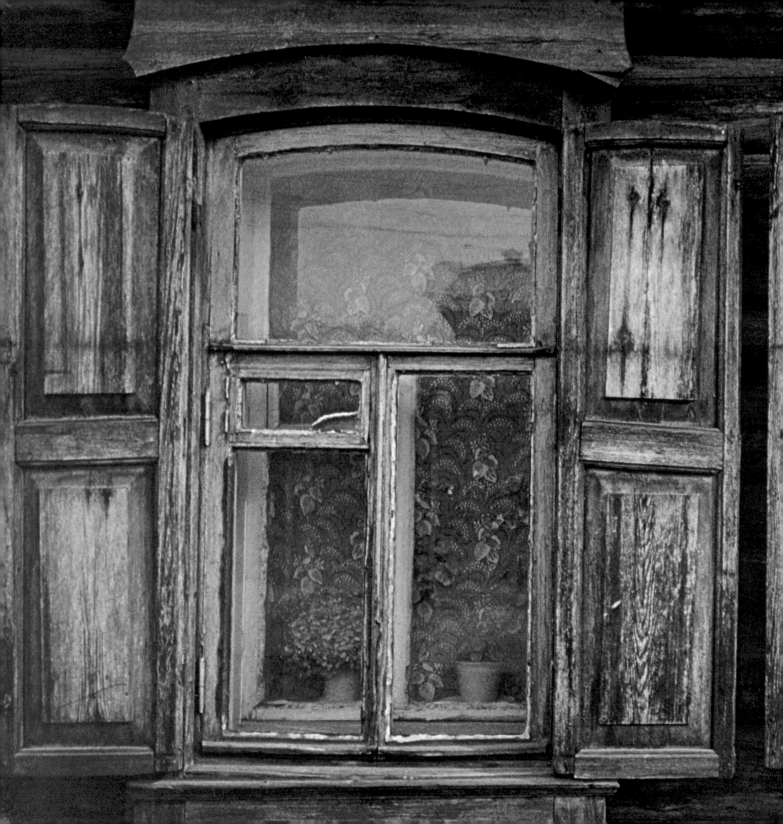

6

Windows have also been called *casements* (from the French *chassis*, a frame); but casement windows came to mean windows hinged vertically to the window frame, sometimes divided down along the mullion, and opening outward or inward like doors. The word *sash* (which also derives from *chassis*) applies to a type of window devised by the Dutch in the 17th century, consisting of two framed sections overlapping at the transom bar and sliding up or down in grooves set in the frame, their movement controlled by weighted pulleys. Both forms are still in common use, despite the recent challenge of sealed metal-framed picture windows, a by-product of the age of air-conditioning.

Fulfilling the needs of a massive population demands mass production. In these days, when housing must take the form of towering apartment

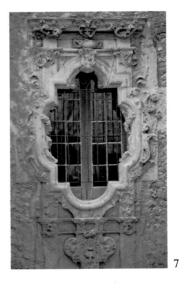

7

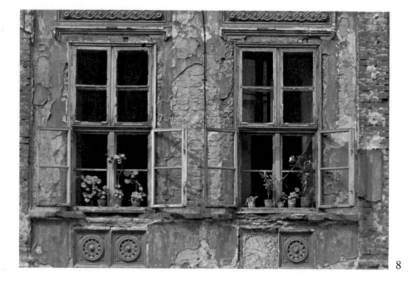

8

blocks with windows of uniform effectiveness, there is a nostalgic pleasure to be found in what was produced when men could be more selective in their demands. Look at the windows of older houses: however shabby, you may find in them a careful craftsmanship and ingenuity, a special attention to particular needs, that probably left as much pride with the men who made them as with the men who eventually owned them. You may be left wondering if the dull efficiency of today's technology is not a sharper goad to unrest than the imperfection of yesterday's.

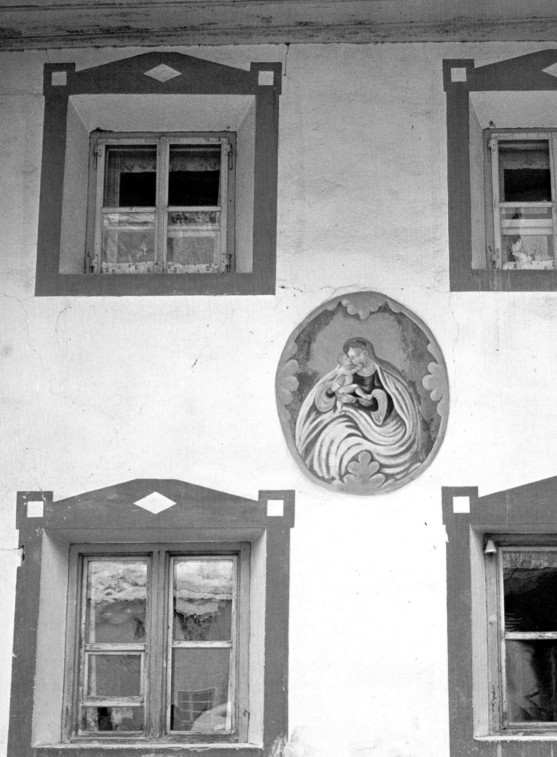

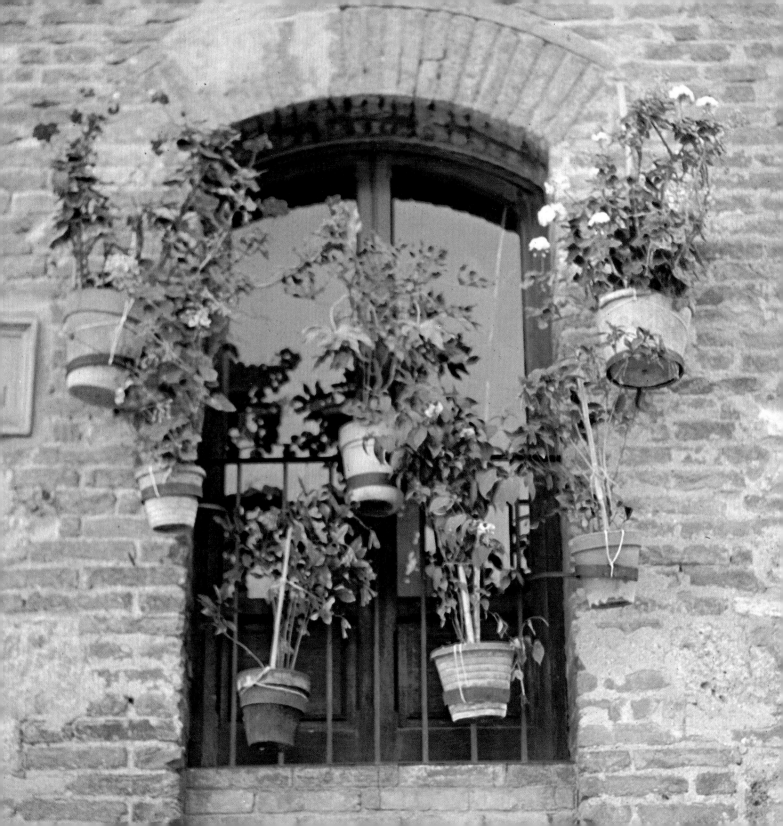

Windows...
*oft made for
looking out.*

For all their intimations of human skill, artistry and history, windows are fascinating because we can look through them. Window-gazing is an addictive habit but, unlike more modish addictions, it is genuinely mind-expanding. A window used to be the most irresistible object in a room. Nowadays another object, the television set, competes for our attention.

It is surely not just an accident that television screens are shaped like windows. But there the similarity ends. Television is the nuclear blast of the information explosion. It irradiates the lives of most of us. By showing all of us almost everything, it tends to obliterate our involvement in anything.

Through our windows—in a sense the oldest form of television—we can watch day after day the unfolding of a serial story, set in a small world that is familiar to us, cast from friends and neighbors to whom we can relate. If we cannot appreciate and understand the lives of those who live closest to us, we may have a problem in coming to terms with ourselves; we will certainly have a problem in appreciating and understanding the lives of people thousands of miles away, even if they are brought into our living rooms by electronic miracles.

11

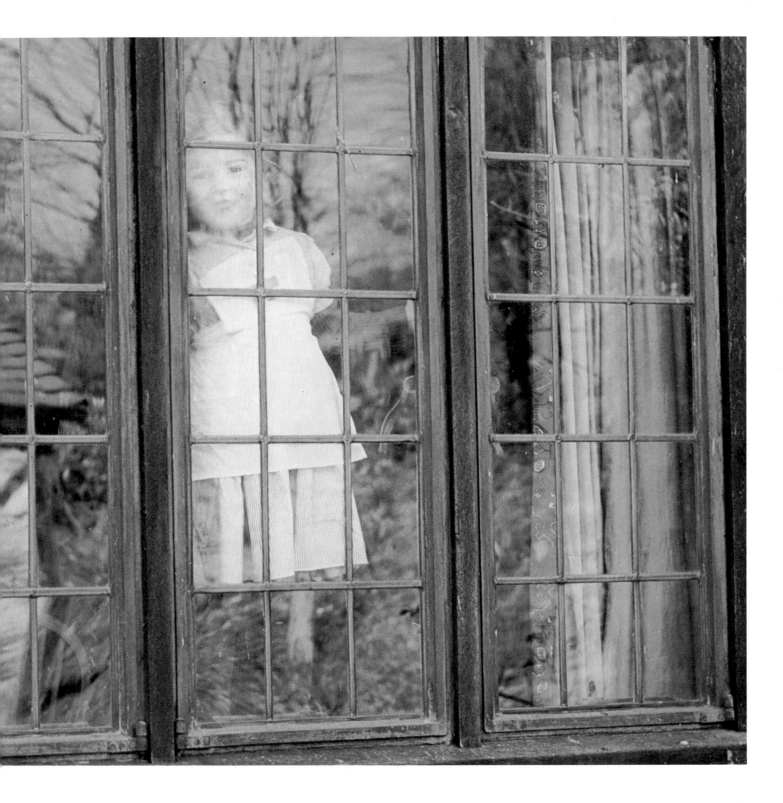

"A good spectator also creates."
Swiss proverb

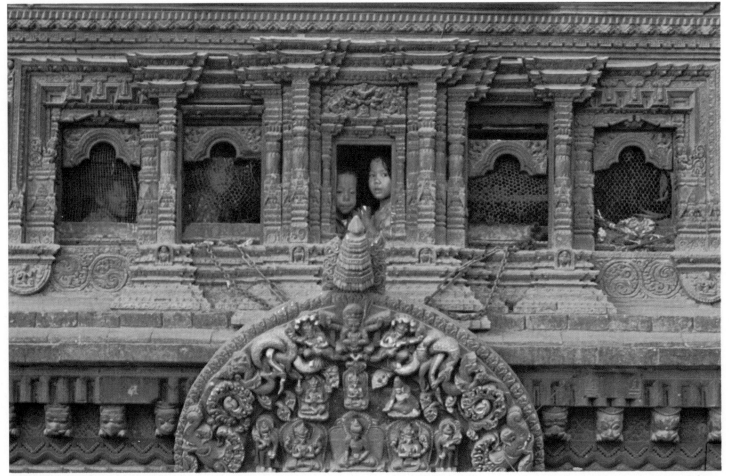

13

14

15

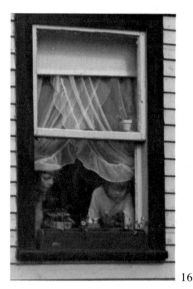

16

Emerson said that the sky is the daily bread of the eyes. The whirligig of snow around a streetlight, the action painting of raindrops on the glass, the granulation of snow under the spring sun and the arrested shellburst of leaf from bud, the touch-and-go of squirrels, the alert opportunism of foraging birds, the congested traffic of ants on the garden path—these are the buffet of eyes at the window.

When did you last look out and see castles in the clouds, mauve vast caverns where thunder musters its big battalions, himalayas of whipped cream, marshmallow armadas bearing down on the city before the wind? Not only does the imagination need nourishment, it also needs regular exercise.

Go sit in the window for half-an-hour—and look.

We may misinterpret and misuse what we learn through our windowpanes, but then we may misinterpret and misuse what we learn from any source. At least windowpanes cannot manipulate what they have to show.

There is the instinct of the spy or the detective in each of us, an excitement of seeing without being seen, an urge to know what goes on "inside." Looking out at what is not intended for our eyes is as irresis-

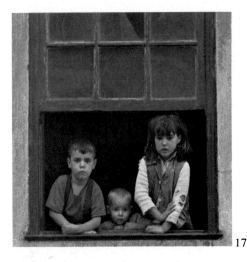

"I have never seen a man who had such creative quiet. It radiated from him as from the sun. His face was that of a man who knows about night and day, sky and sea and air. He did not speak about these things. He had no tongue to tell of them. . . . I have often seen Klee's window from the street, with his pale oval face, like a large egg, and his open eyes pressed to the window pane."

A friend speaking of the artist Paul Klee

tible as peeping in through a window as we pass. What is that friend's mother bringing home in such a bulky parcel? What is he saying to her so heatedly across the table? Who is the stranger holding that girl's hand? Why is so-and-so home early from work today? And what is that neighbor searching for on his lawn? None of our business! To understand we have to learn; to learn we have to observe. Mysteries are the vitamins of the imagination, most effective when taken in small daily doses.

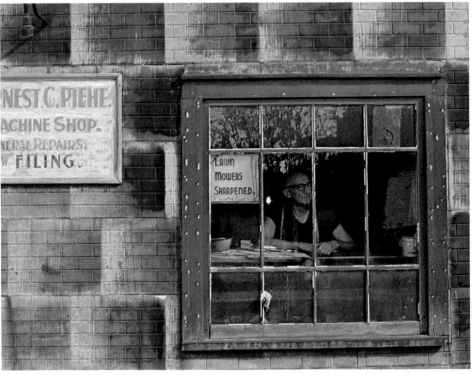

seeing-eyes
in rooftops...

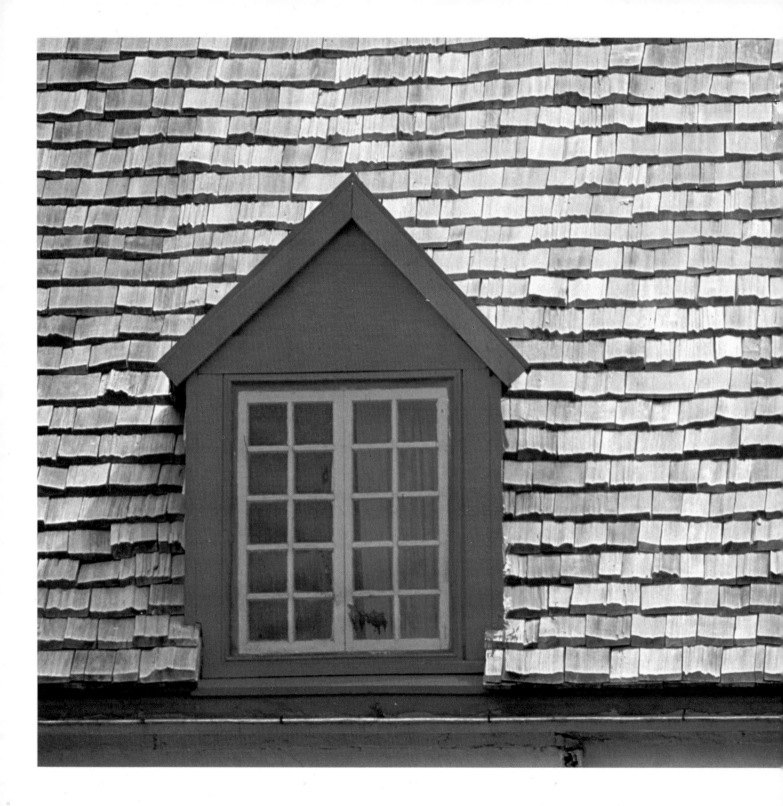

Servants—in the old days when everyone had a set place in the scheme of things—worked in the basement and slept in the attic. Dormer windows, a means by which the ever-practical Dutch and Flemish architects made attics habitable, allowed the lowly an elevated if limited view of the world as well as a breath of fresh air in the swelter of summer. Penniless artists later took over attics, more romantically called garrets, and presumably at the dormer windows the sunlight from outside was matched by the blaze of genius from inside.

In our more upwardly mobile society, of course, the crown of achievement, usually financial, is the penthouse suite. What blazes through the somewhat larger windows is wealth.

I watched out of the attic window
The laced sway of family trees,
intricate genealogies. . . .
Howard Nemerov

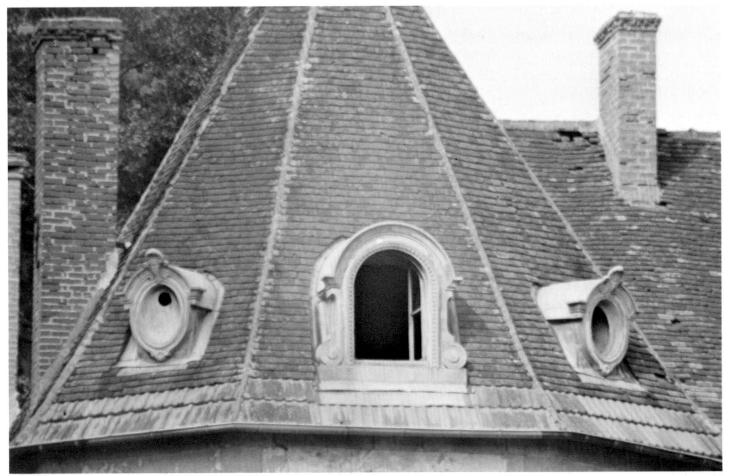

*vistas
round about...*

There are certain views that particular painters or schools of painters have taken lease on for all time, even in the face of change. The reality is captive to the art. Across centuries Canaletto still imposes genius on visions of Venice, Turner on the twilight sweep of the Thames around London, Wyeth on New England, the Impressionists and Post-Impressionists on certain quarters of Paris.

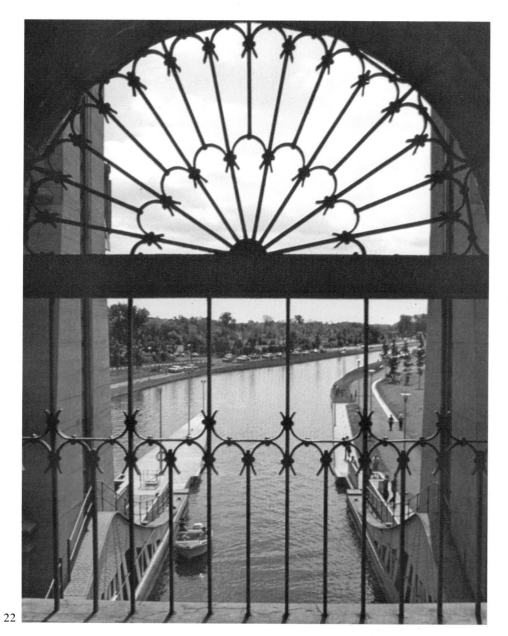

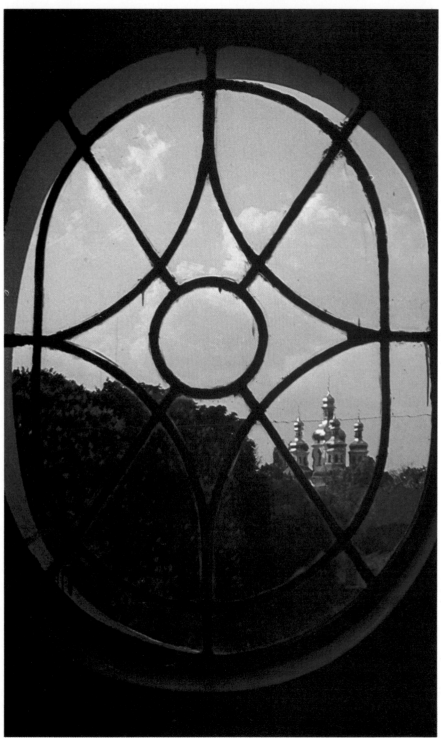

"During the day he loved to sit in a dark corner, and in the evenings he moved over to the window. I liked to sit close to him, neither of us speaking for a whole hour, and watching the black crows circling and wheeling in the red sky around the golden cupolas of the Church of the Assumption, diving down to earth and draping the fading sky with a black net. Then off they would fly, leaving utter emptiness. A scene like this fills the heart with sweet sadness and leaves you content to say nothing."

from *My Childhood* by Maxim Gorky
(translated by Ronald Wilks)

23

To live behind a high window overlooking the geometry of a modern city is to own a collection, the pictures changing hour by hour in the light, created by the Cubists and their abstract heirs.

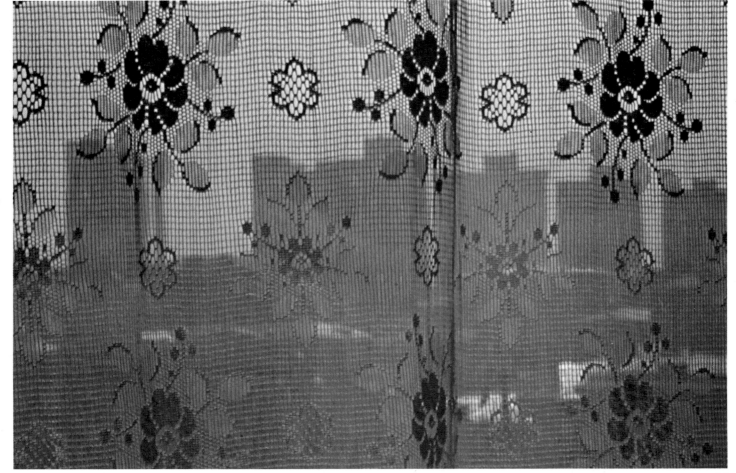

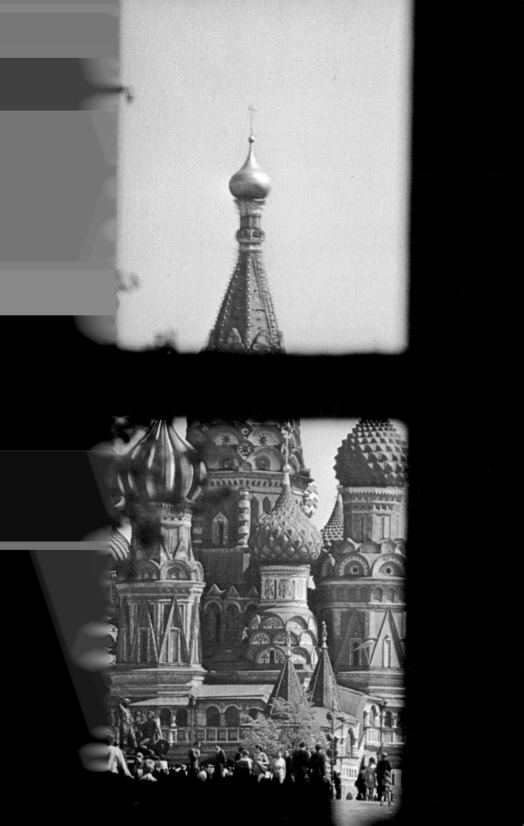

"The beautiful remains so in ugly surroundings."
Malcolm de Chazal

25

of our childhood . . .

First there was the delight of choice. We used to freeze our noses off against the windows of as many as three store windows—candy store, fruiterer's, toy store—in deliberating the expenditure of not many more pennies. Lighted Aladdin's Caves, each with its outspread treasury of tantalizing delight, more gradations of anticipated pleasure than the mind could deal with, more colors and shapes and competing price tags than the eye could cope with, behind the plate glass, frozen, poised for your choice. And next was the joy of discovery. Those black cherries, big and glistening and succulent. Those

26

huge yellow apples. That kite shaped like a hawk, or those steel marbles you'd seen a kid with at school. Or that kind of toffee you'd never seen before, in a painted tin box with impressive lettering. What would that taste like . . . And finally back to choice within the practical confines of value. The kite, but maybe you'd lose it in a tree. Those tangy balls of sugar you loved, five for a penny, but they melt so easily on the tongue. Toffee, clamping the jaw, lasts longer. Or a couple of

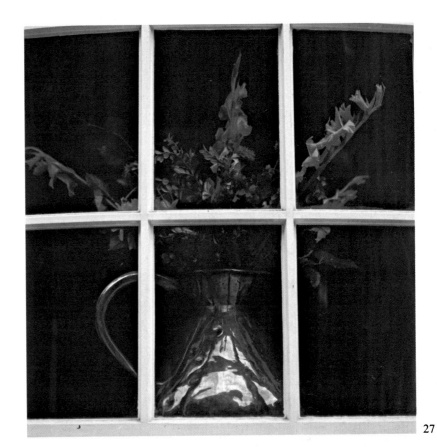

27

"She seemed, with little cries and protests and quick recognitions, movements like the darts of some fine light-feathered, free-pecking bird, to stand before life as before some full shop window. You could fairly hear, as she selected and pointed, the tap of her tortoiseshell against the glass."

from *The Ambassadors*
by Henry James

28

29

30

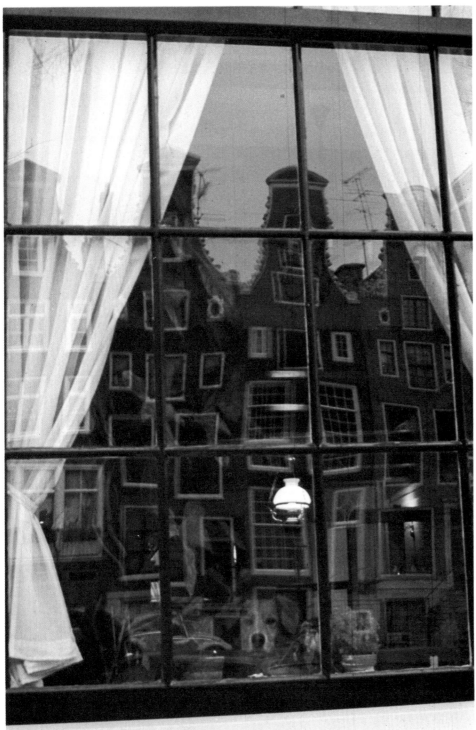

oranges, each peeled section fat with juice . . . You slide to the chosen door, click the latch, the bell above your head tinkles, now imagination faces reality.

We are older and delights seem harder to come by. Hectored from every side by commercials and advertisements, we begin to feel like automatons being programmed to buy what everyone else is buying in supermarkets that every day look more and more like wholesale warehouses. O God of Plenty leave us our freedoms—to choose, to discover, to not decide, to just window shop.

33

32

There survive still, in the older quarters of cities, streets that have escaped the ambitious eye of the developer. Shoulder to uneven shoulder, like veterans in the war against uniformity, stand stores of such bewildering oddness that the stroller is compelled to inspect each one. The meatiness of a Hungarian delicatessen is succeeded by the desiccated mystery of homeopathic remedies, those by the daunting paraphernalia of weight lifters; then used appliances of such tarnished antiquity as to merit museum space; Ukrainian haberdashery supplies; the mute limpness of furriers' remnants; a Lebanese restaurant, also offering occult jewellery; outfits for the Oversize Man; a Philippine grocer; surplus war equipment and aquarium supplies. . . .

We have not lost our sense of wonder if we can be halted to contemplate a modest brass ashtray supported by immodestly entwined ceramic nymphs in gold and pink. Or by a battered aluminum machine for rolling your own cigars, drastically reduced. Or the rich sheen of antique copperware. Or the dimmed title page of *A Treatise*

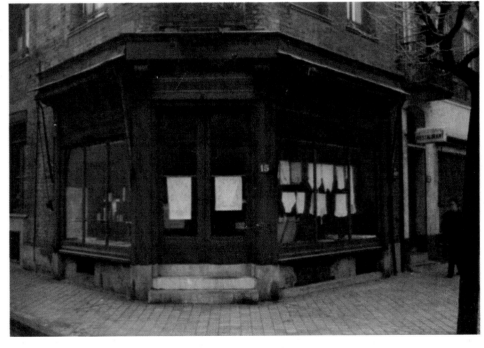

Upon The New Sovereign Cure For Bloody Flux. Or a tall jar of antipasto layered like a column of marble. Or a coonskin cap. Or a Japanese kite shaped like a dragon. Or a spread of old-style candies. . . . Gazing in such windows, we may see reflected the way we were. Or perhaps the way we wish we were.

34

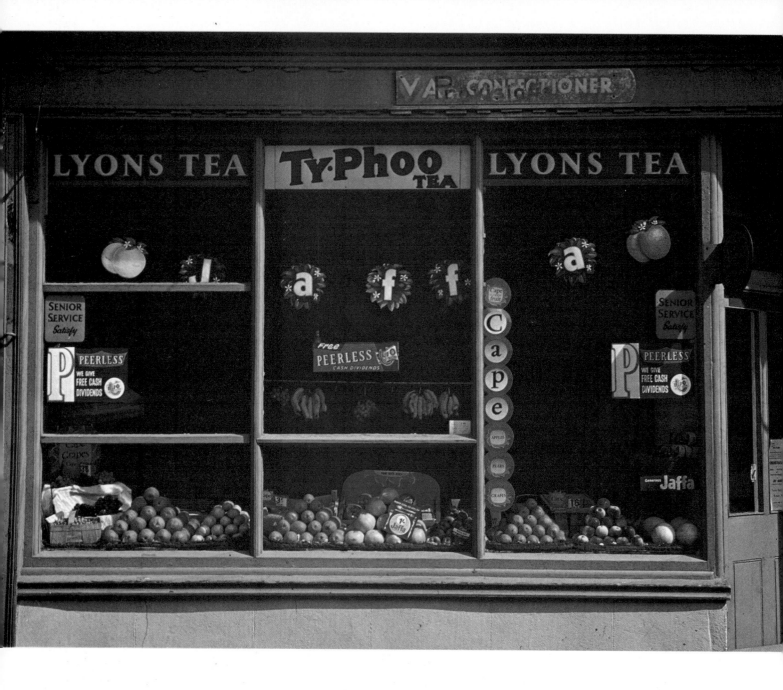

*things that
nothing hides...*

The facades of houses, like the clothing of most people, tell us little more than their condition in life. We can pick out in a passing glance the houses of the rich, the middle class and the poor. We really need to examine the windows, as we instinctively meet a stranger's eyes, to glimpse something of the character of those within.

"The Betlengs' was a noisy, riotous household, made up of many beautiful young ladies who were visited by officers and students. They were always laughing, shouting and singing, and playing guitars. The house had a gay look, its windows sparkled and through them the bright green of potted plants could be clearly seen from outside."

from *My Childhood* by Maxim Gorky (translated by Ronald Wilks)

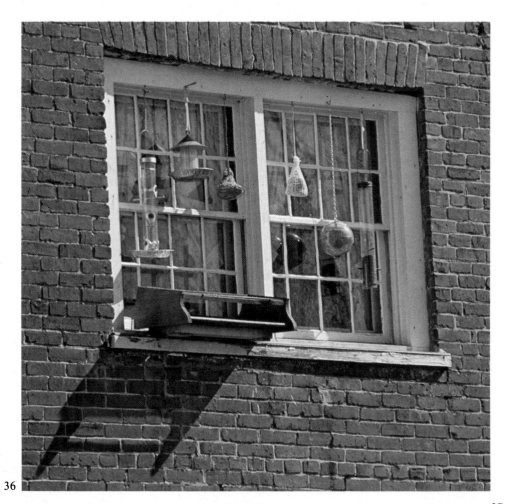

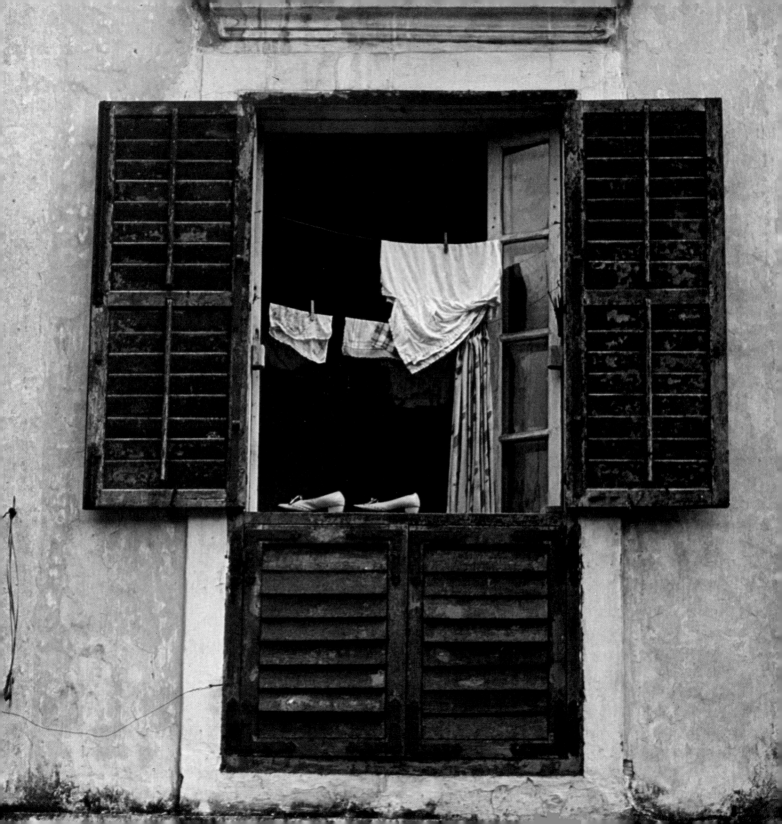

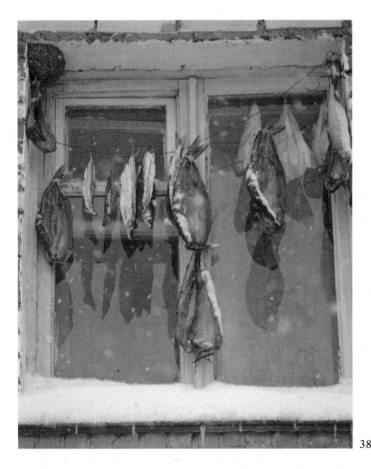

38

Most of us are more easily attracted and won over by those who wear their character on their sleeves. So unaffected windows, which seem to have nothing to hide, earn our passing affection.

Windows are logical showcases for those valued trifles that we wish to be shared and admired. Or that we ourselves wish to contemplate and enjoy, since our eyes within a room

tend after all to orient toward the light. Again for the untidy, windows are the last refuge for those things that don't quite have a place: they are the attics of the cluttered room. And of course even those who don't have a hothouse or a herb garden or, for that matter, a clothesline, do always have a window.

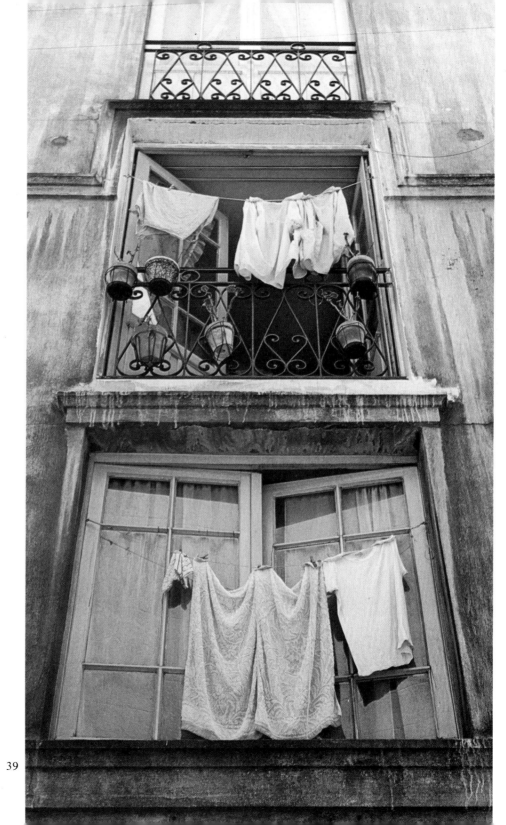

39

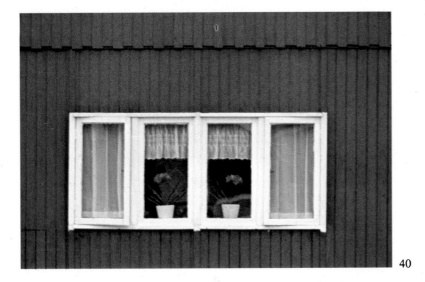

40

It is no mere matter of observation and conclusion. We cannot stop and stare at what we see in other people's windows as we might before a store window. What we glimpse in passing may interest us, may amuse us, and then may intrigue us for days on end. A neat window box may conjure up the careful gentility of a widow, an empty bottle on a window ledge the frustrations of a bachelor, a line of underwear the struggling economies of a small family.

We can never confirm our insights. But mysteries solved are mysteries dead. Long live the mysteries of things in windows!

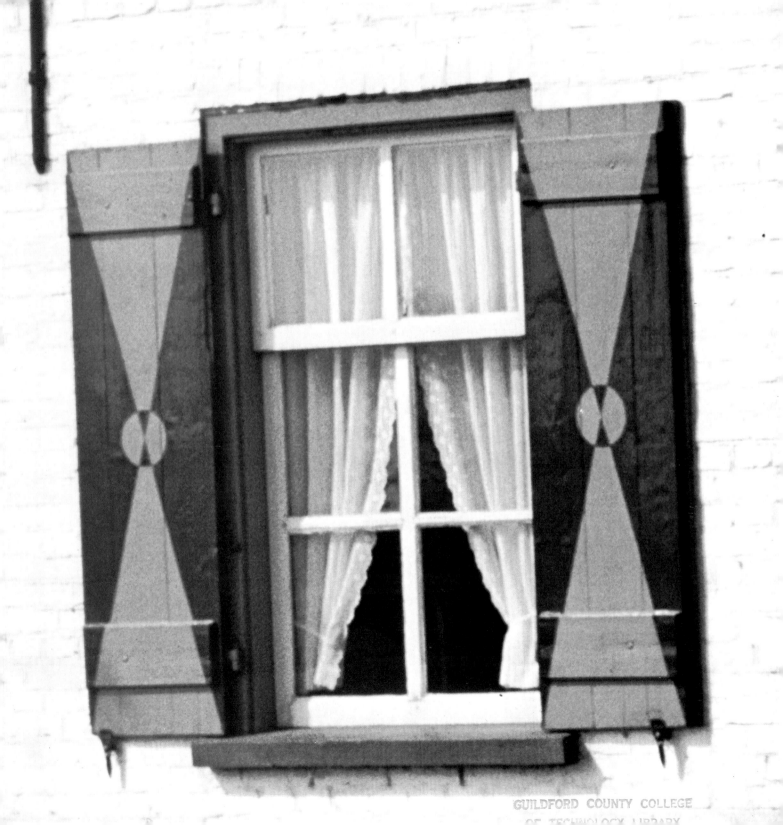

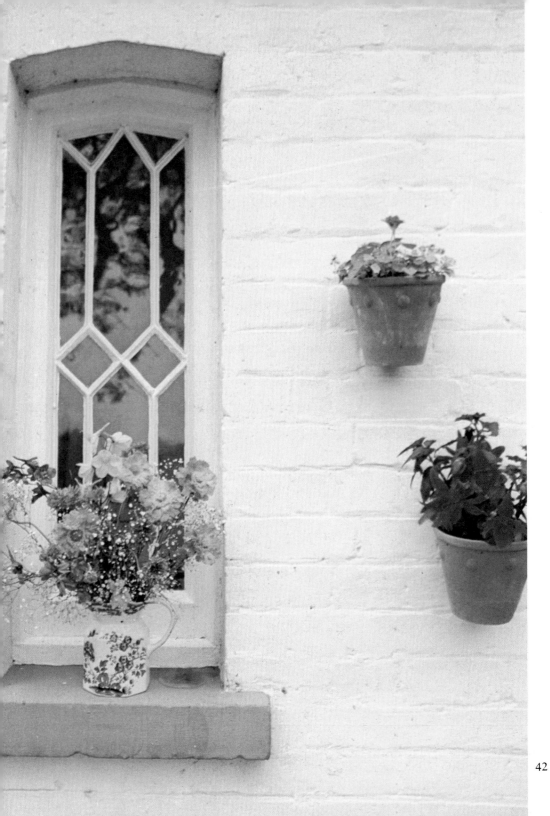

*recalling times
primeval...*

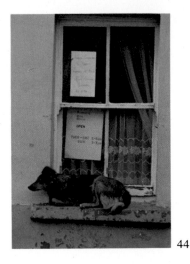

44

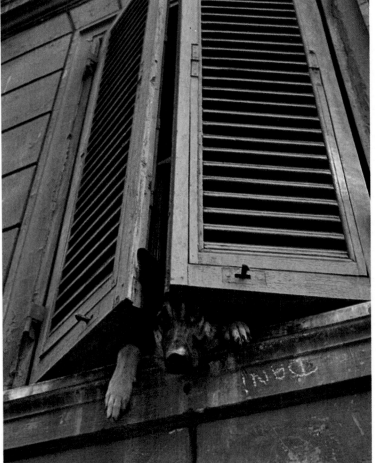

43

Windows are as compellingly attractive to pets as lighted stages are to actors. Even if centuries of domestication have conditioned their species to fitting behavior within a house, there lurks in each of them residual instincts attuned to a world outside where a different law prevails. They may have developed an aversion to the perils and discomforts of that life outside, but at the window they may at least sense their age-old ties with the wild world beyond the glass and may even act out a vicarious involvement in it. The window is their limelighted stage.

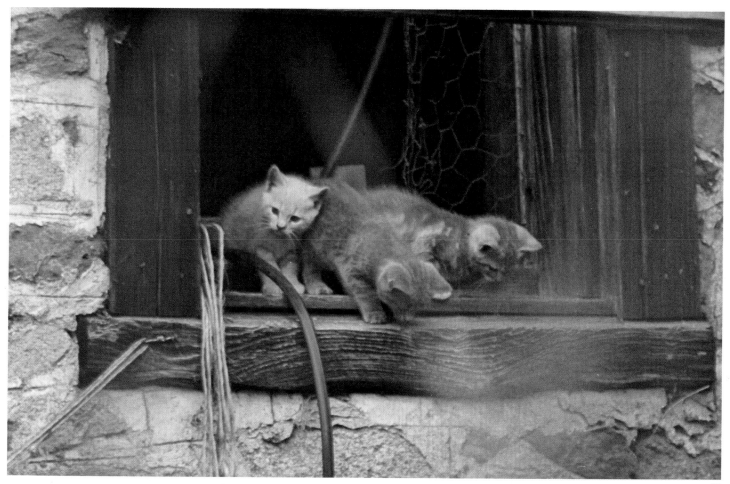

Pets are, after all, consummate role players. Within the theater of the home they have learned exactly how to attract and captivate their human audience, how to feign within artistic limits all the emotions demanded by their repertoire—abject devotion, undying loyalty, unthreatening ferocity, heart-warming pathos.

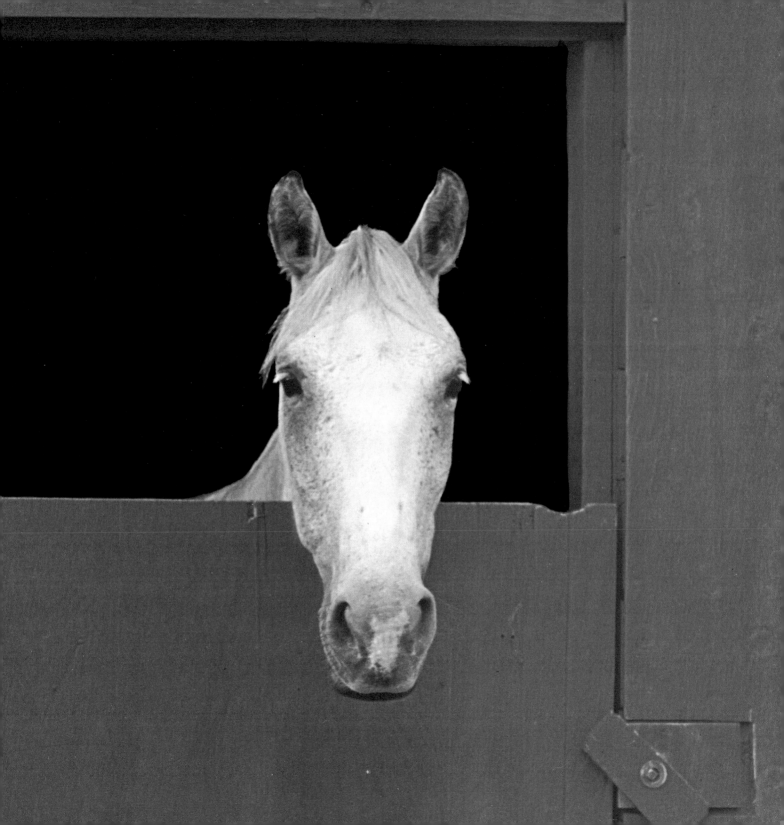

Apart from canaries, budgerigars, and a few parrots, exotic pets no longer enliven windows. Sad . . .

47

Here, secure behind plate glass, yapping little Pomeranians may act out the savage assault they would launch (but for human restraint) on every Great Dane or German Shepherd or laden mailman daring to invade the household precincts. Here the mongrel may lie in highly visible dejection, awaiting with one open eye the cue for his tailwagging elation at the approach of his master. And here, protected from the exposure of their inability to do so, sleek fat cats may mime the stalking, pouncing upon, and devouring of those provocative agile squirrels on the lawn. But have squirrels learned, living as they do within the periphery of the humanized world, that those natural enemies behind glass are powerless, for all their window-ledge antics?

Curious, isn't it, that wild animals, unless they're accustomed to getting scraps and crumbs, are far less interested in what people are doing inside windows than people are in what animals are doing outside?

48

"It happens through the blond window, the trees
With diverse leaves divide the light, light birds . . ."
Denis Devlin

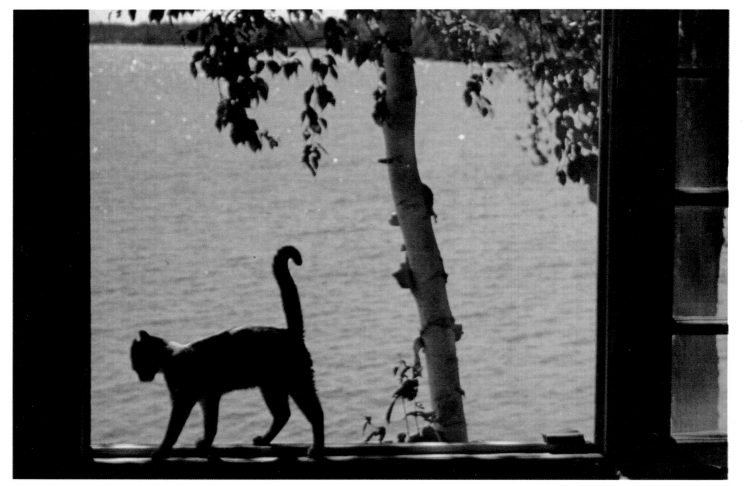

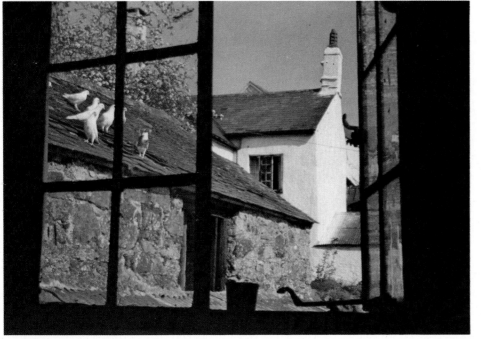

50

" . . . At last we would go to bed, bolting the doors while the lemurs cried in the moonlight, house-ghosts bounding from the mulberries to the palms, from the palms to the tall pines whose cones the dormice nibble, from the pines to the roof and so to our bedroom window where they would press their eager faces to the pane. . . . The two lemurs are admitted and worm their way down to sleep in the bottom of the bed. In the morning they will creep out round our feet, seize the aromatic toothpaste in their long black gloves, jump with it through the windows and spring down to the sunny earth by the way they came."

from *The Unquiet Grave*
by Cyril Connolly

*showing
all we
feel inside...*

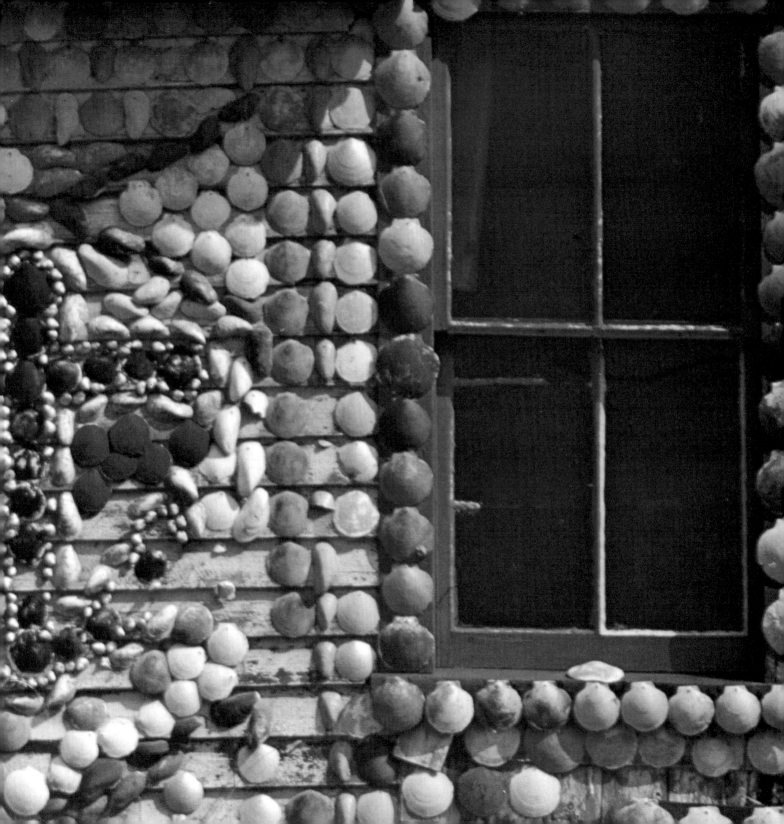

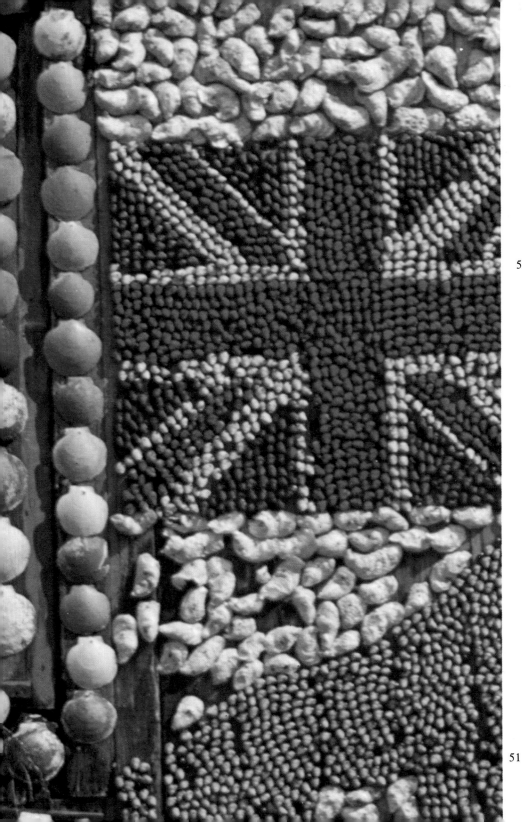

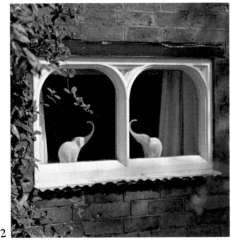

And for those of us who don't have pets, there are always the beasts of heraldry and art.

Because windows attract the attention of the passing eye, they tempt us to display not merely our treasured possessions but our fantasies and passions and yearnings. Loyalty and patriotism, nostalgia and wanderlust, ambition and political allegience, love of nature or of past elegance—in our windows we may symbolize and signal what we might hesitate to say.

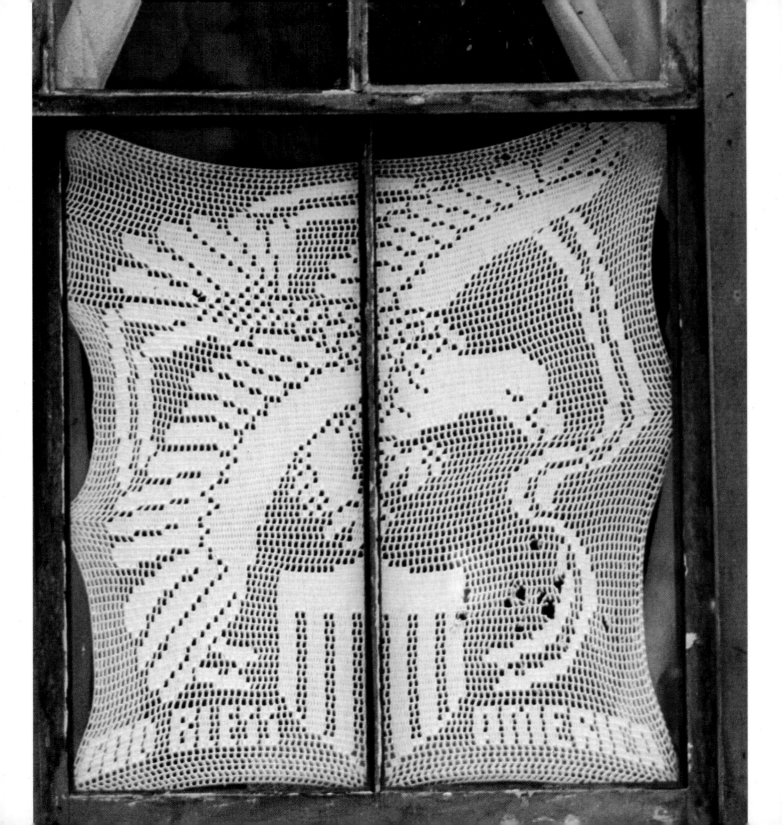

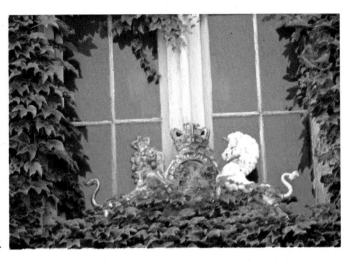

54

Even our eyes, which
can tell a stranger so much
about our inner selves, cannot
match our windows in showing
the world what we really feel.

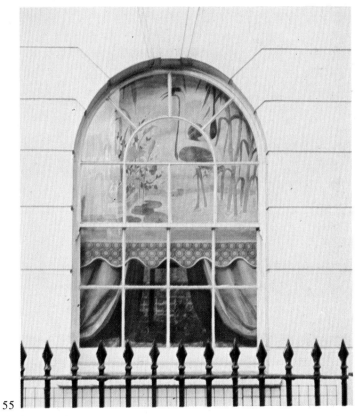

55

56

There are individual windows, because of their particular design or because their owners have enhanced them in some way, that catch our attention and force us to admire them or wonder at them. And then there are the great buildings and splendid homes, the work of master architects, that arrest us because of the studied perfection of their design and construction. They were conceived to impress the world, and the world pays due homage. What we sometimes miss is the delight of discovery. In all probability we have heard of these architectural masterworks, and have come especially to feast our eyes on them.

The reality tends to fall short of the anticipation.

But then, every so often, we chance upon some humbler building, simply intended to fulfil some very ordinary purpose, where the original builder (or some nameless craftsman later called to improve it) has managed to create from very ordinary parts, windows, doors, trim, a striking and extraordinary whole. It is the kind of random encounter that leaves an afterglow in the mind, like the glimpse of a fascinating unknown face in a crowd.

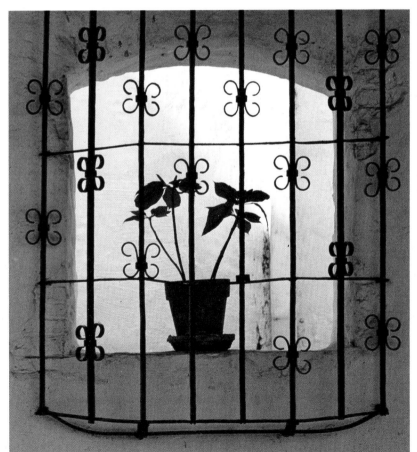

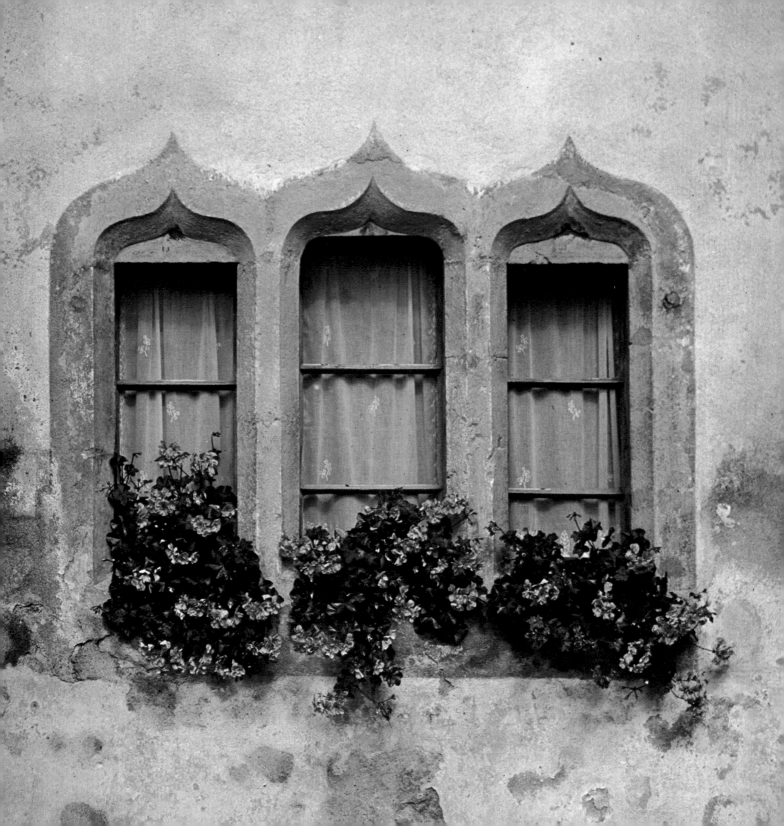

*small
and tiny . . .*

61

Small windows, like small children, are indulged in their non-conformity. They are, often as not, architectural afterthoughts, providing for some unforeseen need with as little expense and trouble as possible, a gleam of light for a dim lobby, a breath of fresh air for an extra washroom or kitchen, maybe even a spy hole to cover the approaches to a blind side of the house.

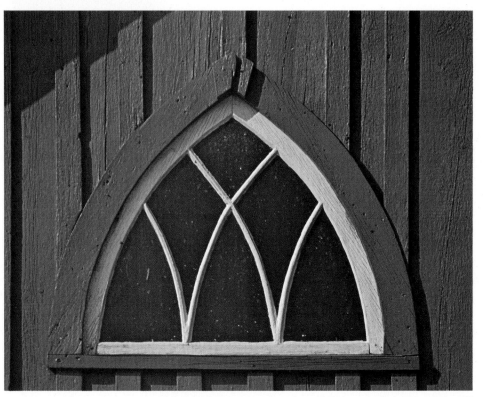

62

In Middle Eastern houses, where thick unbroken walls are counted as the best defense against the blazing sun, a few such apertures, deep set enough to exclude direct light, may be the only windows, maintaining a tradition first established thousands of years before Christ.

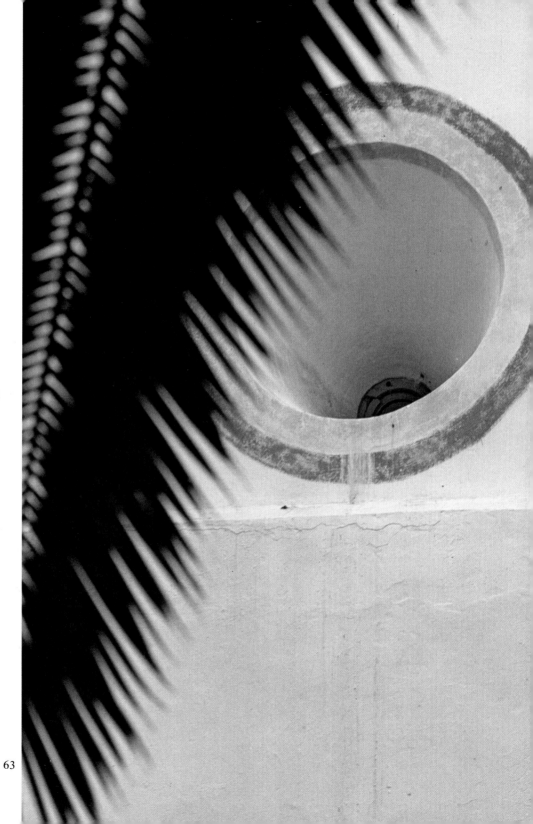

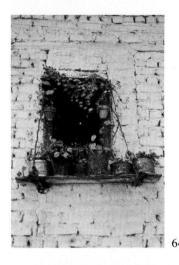

64

In classical European architecture, there are a few minor windows that deviate from the norm by tradition. Circular *Rose* windows, often with their panes divided by lead tracery, were traditionally set over the main doors of public and religious buildings. *Fanlights* were a common feature over the doors of Georgian houses, shaped as their name suggests. And *Lancet* windows, again aptly named, were an early result of the development of the arch in construction; normally they are long and narrow.

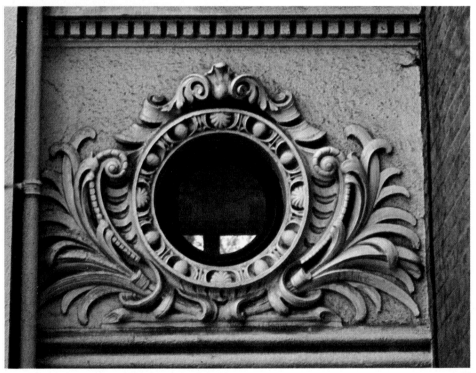

65

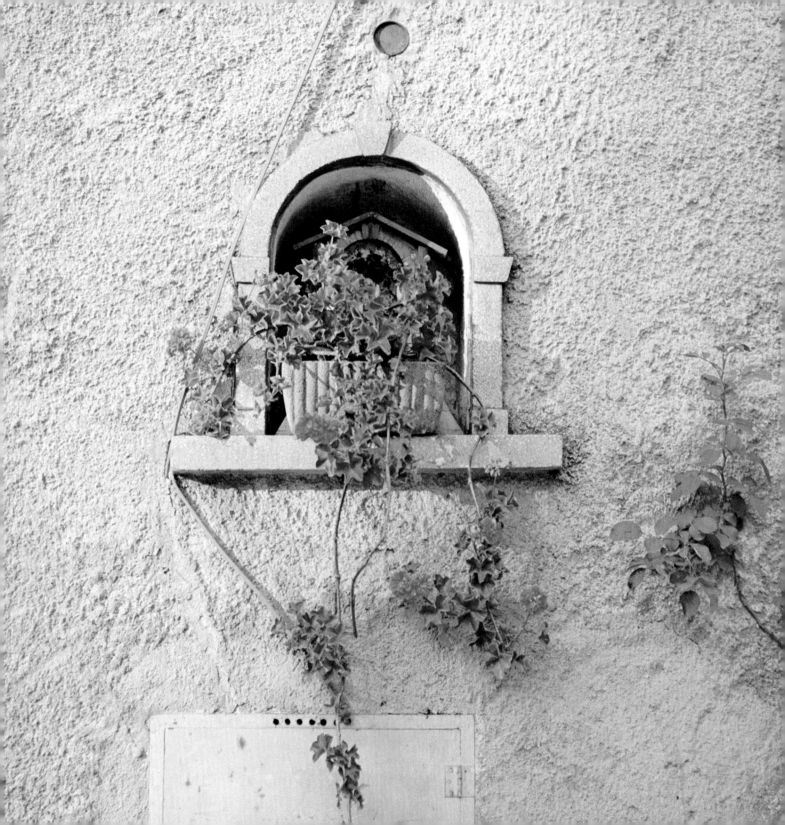

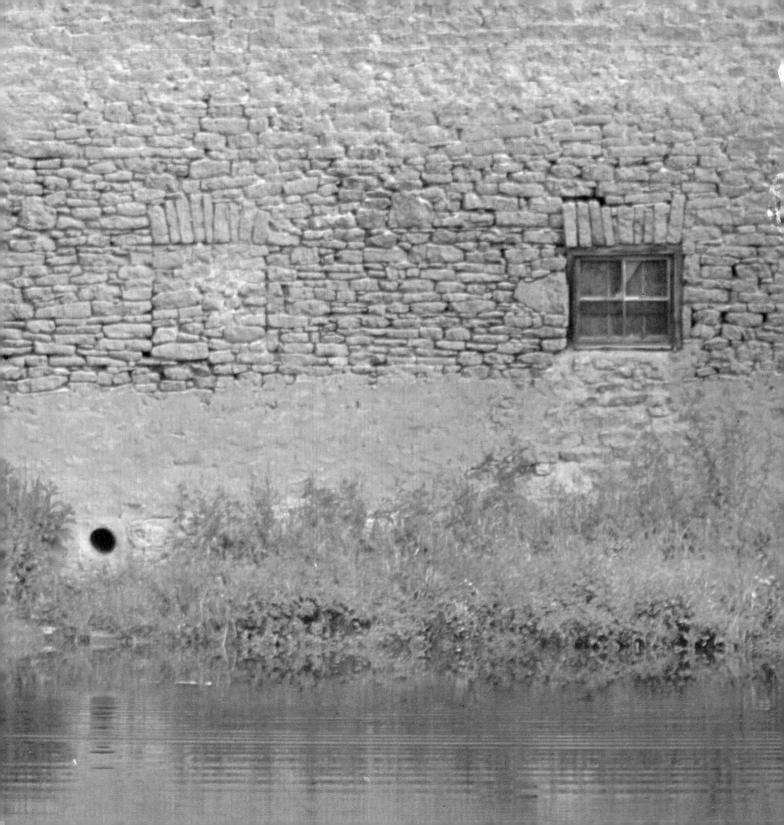

*cloaking
secrets from
the world . . .*

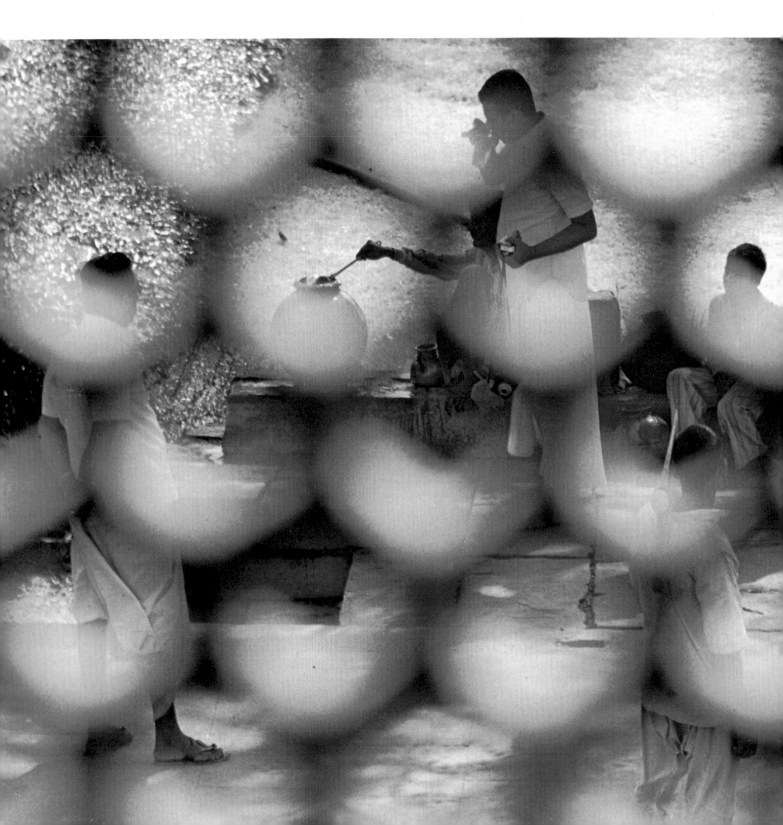

There's a certain irony in the fact that as the right to personal privacy has increased so have the number of windows through which we can observe and be observed. Until medieval times there was virtually no privacy for the common people, living as they did in the communal chaos of the extended family. And even among the privileged, privacy was a privilege hard to come by. The word *curtain* derives from the Latin word *cortina*, meaning a little court or enclosure. So presumably even the Caesars, subject to the open-plan interiors of their day, had to resort to curtains in order to wheel and deal and ponder the cares of empire.

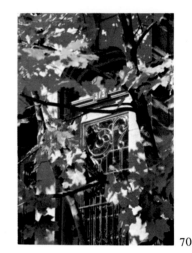

70

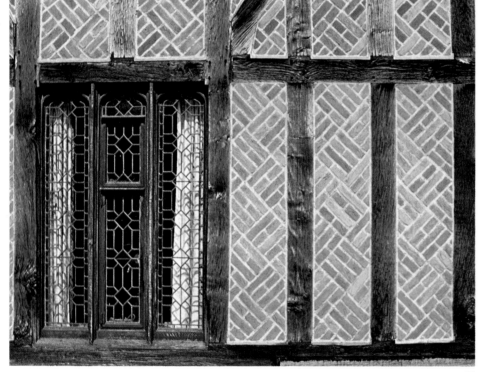

69

Curtains, screens, shades, shutters, and indeed leaded windowpanes have remained the defenses of those who wish to keep themselves to themselves. But inevitably, like all weapons of defense, such impediments excite curiosity as much as they deter it. If something is going on that needs to be hidden behind screen or curtain, we need to know what all the more urgently.

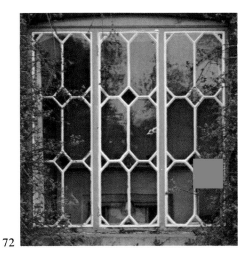

72

73

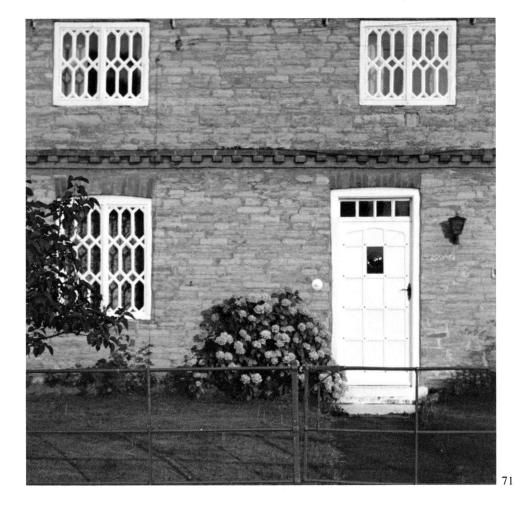

71

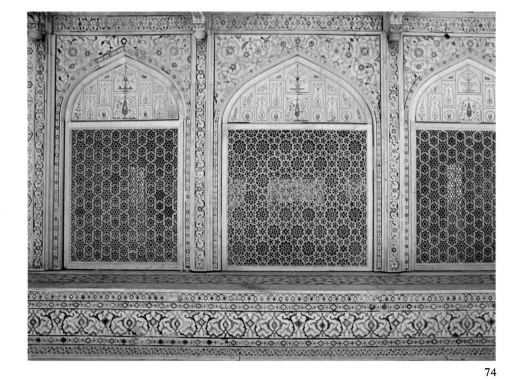

Lace curtains don't necessarily imply modest isolation. They have long served as the weapon of the busybody who must see, without being seen, everything that happens on the street. But for a time they proved to be a double-edged sword in the small wars of the suburbs. How could competing busybodies, each behind curtains, know when their adversaries were also watching and how could they dare venture out to exchange intelligence with allies when they might be secretly observed themselves!

75

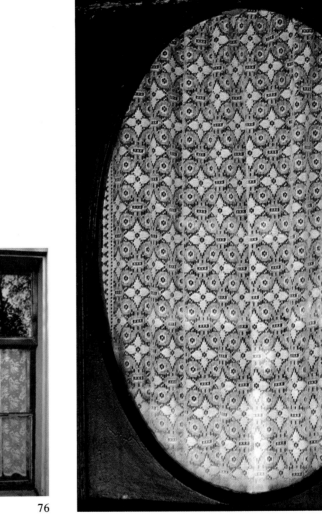

76

77

Until Alexander Graham Bell
revolutionized curtain cam-
paigning with his invention, a
street had to be as stealthily
traversed as an actual no-
man's-land.

What would our writers of thrillers have done without windows—symbols and instruments of intrigue and menace? The positioning of potted plants on the ledges of embassy windows has been used more than once, in both fiction and reality, as a covert means of signalling to secret agents. What hero, out in the midday sun, has not felt a cold chill down his spine at the sense that many eyes were following his movements from behind the latticed windows of the native quarter?

78

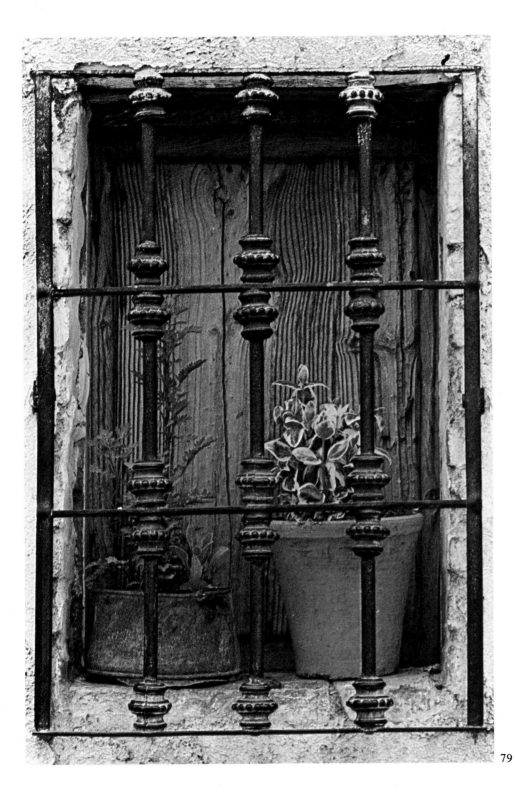

79

80

And behind the sad lace curtain of a shabby cottage, what new challenge awaits the ingenuity of the botany professor turned detective?

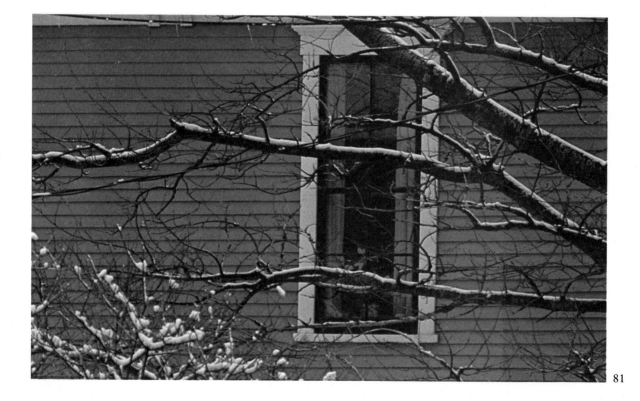

revealing faith
in Heav'n . . .

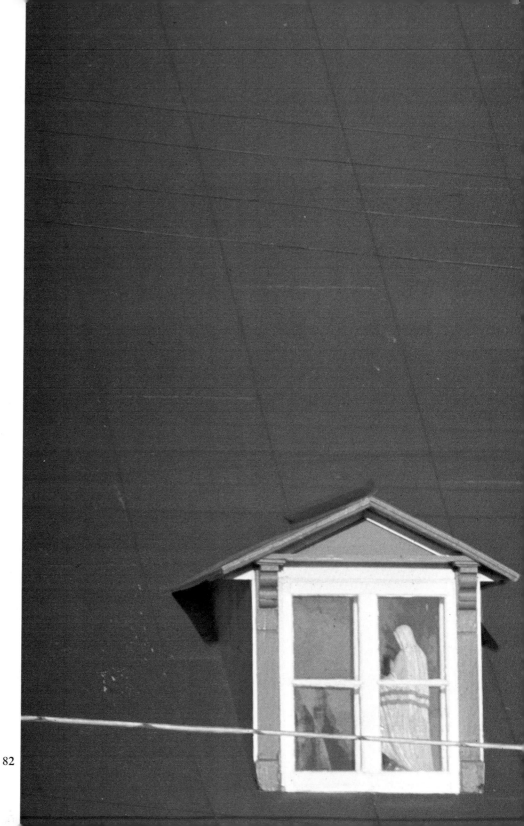

In Roman Catholic countries, especially where a show of Faith has remained a simple and natural duty, statues of Christ, of The Virgin or of some patron saint have always claimed a place of honor in windows, either as guardians of the home or as a reminder or service to passersby. And of course, window ledges provide a perfect setting for a family shrine.

82

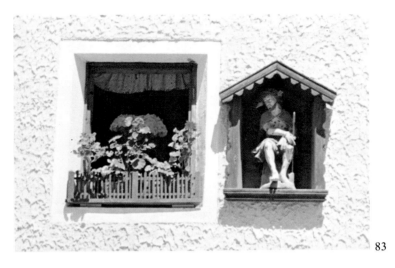

83

"The same day were all the
fountains of the deep broken
up, and the windows of Heaven
were opened."

Genesis 7:11

84

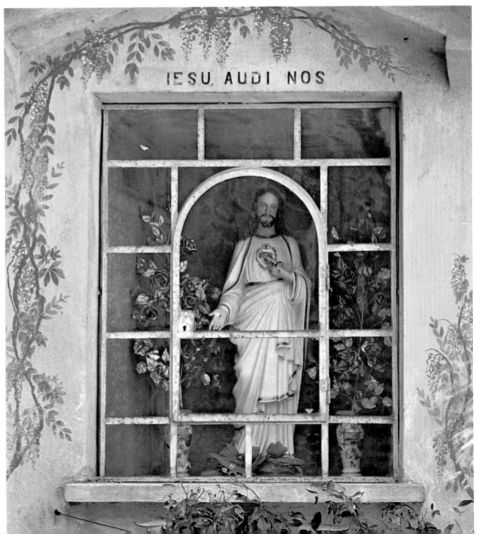

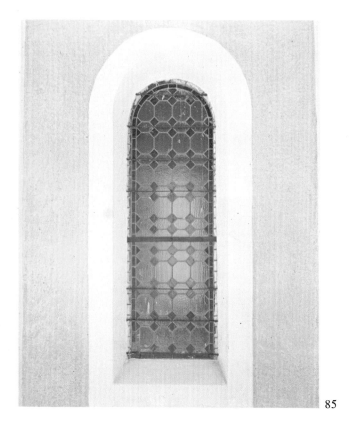

85

In the earliest Christian churches, the high windows, initially unglazed but later glazed with clear or plain tinted glass, served to illuminate murals that depicted the story of Christ, a necessity in times when few of the congregation could read. Eventually those religious pictures were embodied in the windows themselves in stained glass. The earliest use of stained glass occurred late in the 10th century, but it was not until improved building techniques allowed greater expanse of window and until methods of tinting and etching glass had been perfected that stained glass reached its summit of artistry, some 400 years later. The Reformation, which accused the Church of Rome of idolatry, brought a revulsion among the more extreme Protestants to all religious art, including stained glass. Among more moderate Protestants, stained glass windows have survived, but often formalized or merely decorative. Decline of the craft, economic necessity, and changes in lay taste are nowadays more telling factors than sectarian dogma.

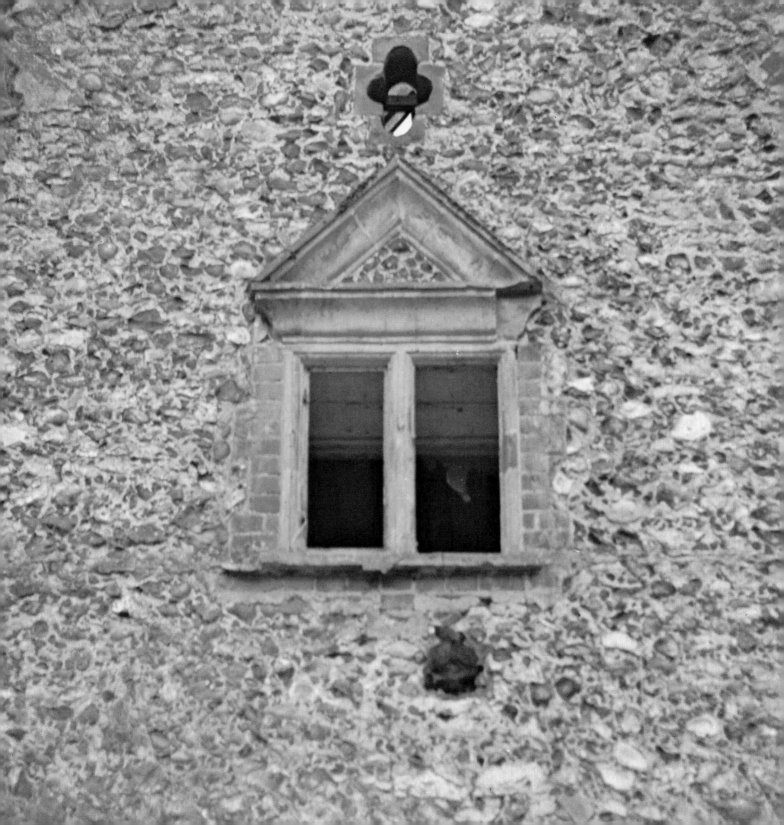

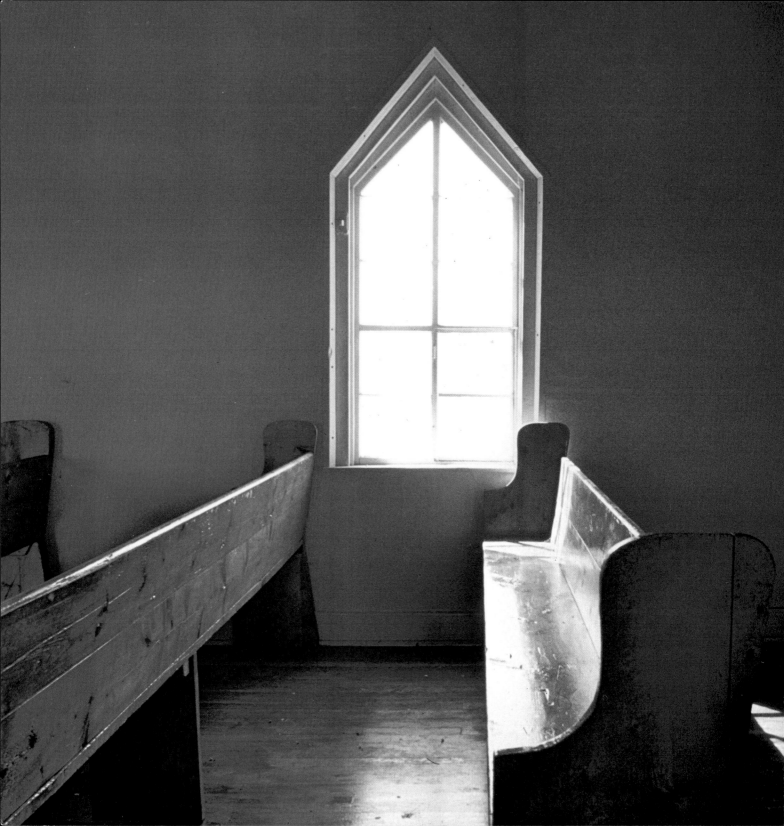

Lord, how can man preach thy eternal word?
He is a crazy brittle glass;
Yet in thy Temple thou dost him afford
This glorious and transcendental place,
To be a window, through thy grace.

Georg Hegel

87

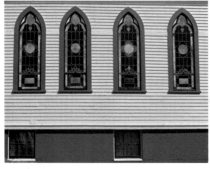

88

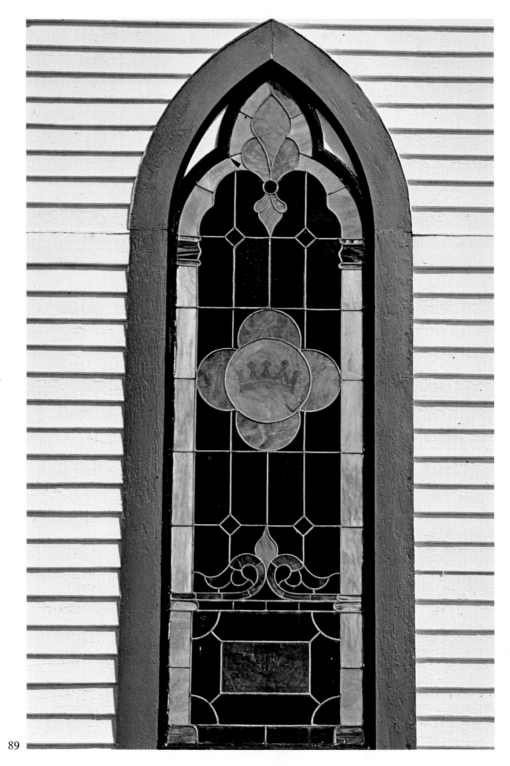

89

*hiding
Mammon's flag
unfurl'd...*

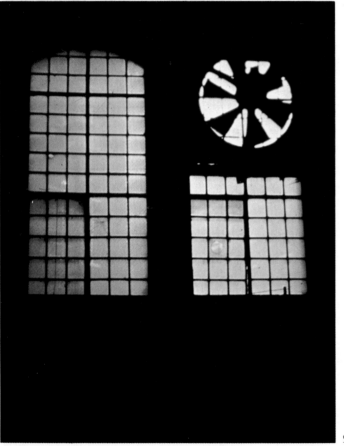

It is significant that even in those polished towers, composed mostly of glass, that house the white-collared end of commerce and industry, access to windows is usually a matter of privilege. The productivity of general offices and typing pools is thought by many to flower most vigorously under fluorescent light at the core of such buildings; bosses and executive personnel are usually presumed to require an inspirational view of the outside world and the horizon. The less edifying aspects of industry, of course, have been rendered virtually invisible.

It was not always that way. Originally manufacturing

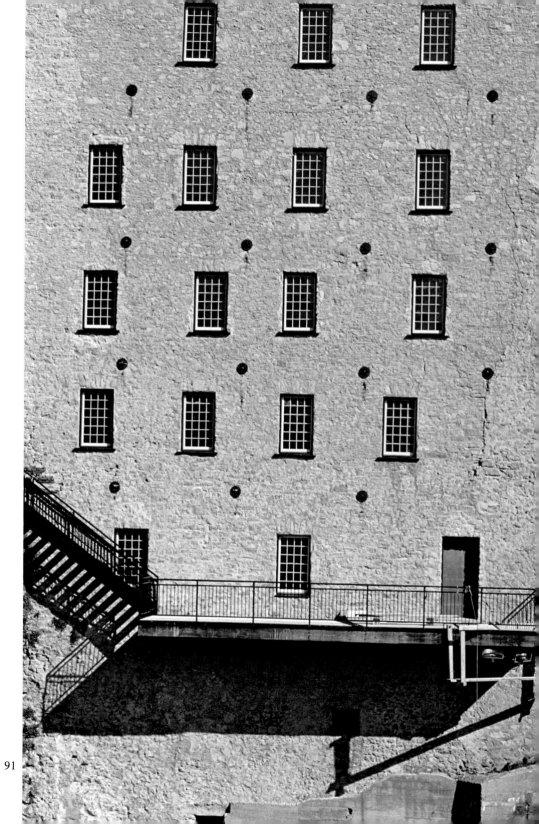

towns tended to expand from
a hub of multi-storied mills
and plants, structures as im-
posing as cathedrals and ap-
propriately so, since enterprise
was the religion of the day.
They had windows, often as
large and as ornate as those of
their religious prototypes; and
they needed many windows to
supplement the sputtering
coal-gas or kerosene illumina-
tion on which they depended
otherwise. Those high win-
dows stared out balefully
across the humbler residential
areas, as though making sure
that nobody neglected the reli-
gious duty of attending work.

Such windows, like the build-
ings they are set in, are anach-

91

ronisms. They are relics of a time lag in the industrial revolution, when the need for massive production facilities had outstripped the technology of lighting. When electricity arrived, the windows for the most part became superfluous. Windows, as we each know from domestic experience, need constant care. Whether for reasons of economy, or apathy, or from some managerial instinct that visual contact with the world outside will encourage daydreaming and evaluation of the passing parade, the windows of such relics as survive are invariably left encrusted by the internal and external pollution of decades. As a result, those of us who have never worked in foundries or machine shops have grown up with no concept of their reality other than the blurred image of ranked floodlights seen through windowpanes only slightly less opaque than brick. They have left many of us with an attitude towards industry that is composed in equal parts of awe, distaste and suspicion. Whatever goes on in places that need to be cloaked in such obscure neglect, we conclude, cannot be good. The fact that most industry in the meantime has sited itself almost invisibly on the rims of our cities, in low anonymous buildings devoid of windows and dirt and noise, has done little to dispel an image of the work-place defined in William Blake's ''dark Satanic mills'' and in period novels.

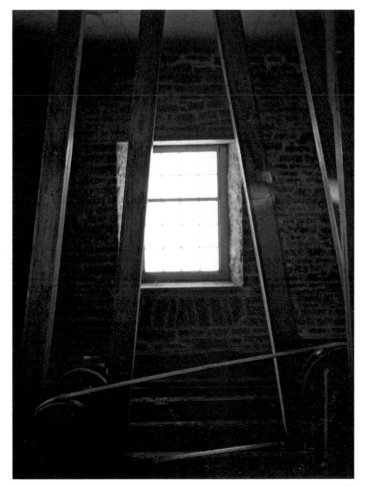

92

93

"Price's works was small, old-fashioned, and out of repair—one of those properties which are forlorn from the beginning, which bring despair into the hearts of a succession of owners, and which, being ultimately deserted, seem to stand forever in pitiable ruin. The arched entrance for carts into the yard was at the top of the steepest rise in the street, when it might as well have been at the bottom; and this was but one example of the architect's fine disregard for the principle of economy in working—that principle to which in the scheming of manufactories everything else is now strictly subordinated. . . . Such was the predicament when Anna assumed ownership. As she surveyed the irregular and huddled frontage from the opposite side of the street, her first feeling was one of depression at the broken and dirty panes of the windows . . . decrepit doorways led to the various 'shops' on the ground floor; those on the upper floor were reached by narrow wooden stairs, which seemed to cling insecurely to the exterior walls. . . . The office was a long narrow room, the dirtiest Anna had ever seen. If such was the condition of the master's quarters, she thought, what must the workshops be like? The ceiling, which bulged downwards, was as black as the floor, which sank in the middle till it was hollow like a saucer. A greyish light came through one small window. By the window was a large double desk, with chairs facing each other."

from *Anna Of The Five Towns*
by Arnold Bennett

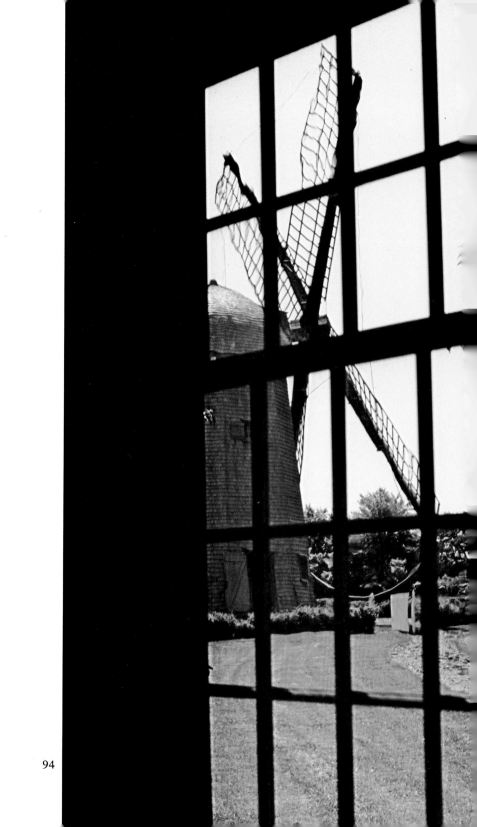

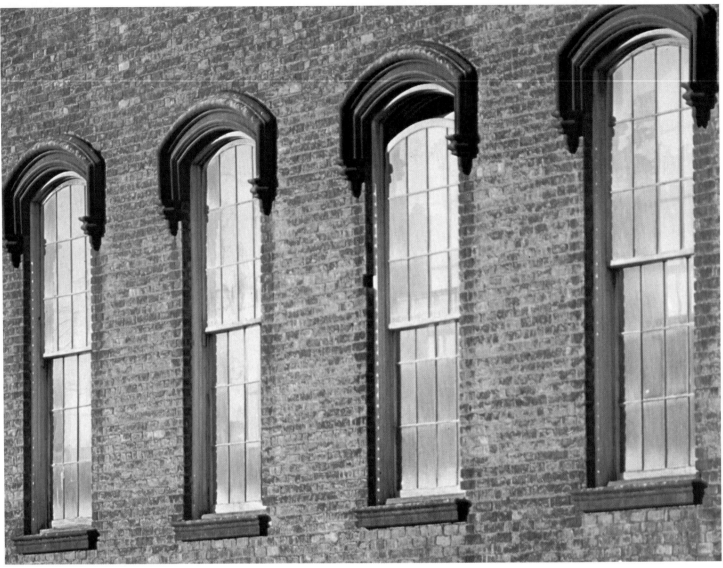

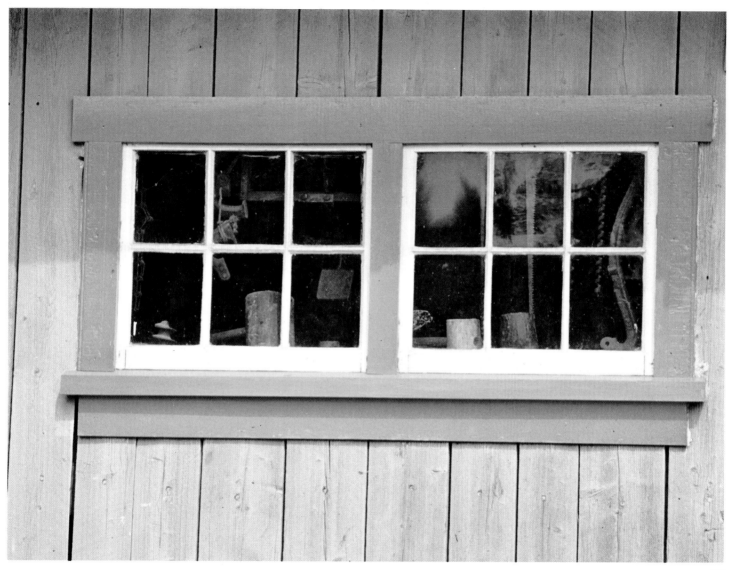

97

98

99

GREAT S

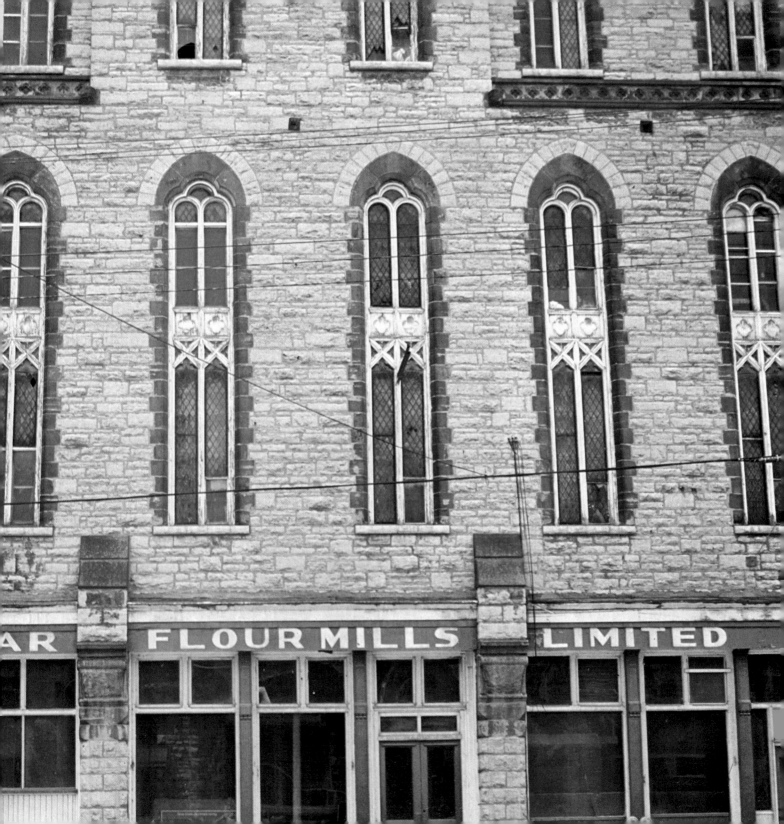

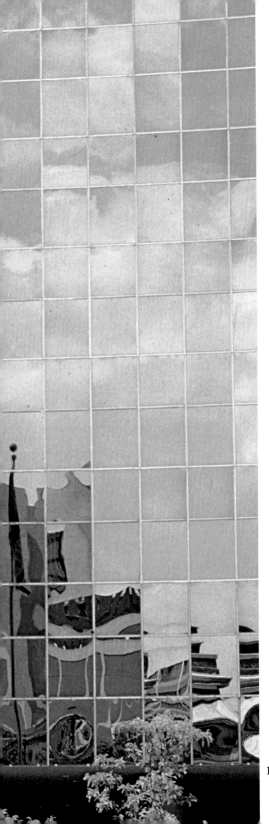

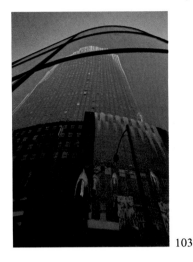

103

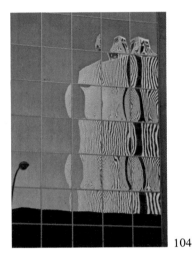

104

Back in the real world, a new obstacle faces window gazers. Until the middle of this century, corporate and government headquarters used to gird themselves with edifices as solid and secure and sparse of windows as fortresses or penitentiaries. Then architects managed to persuade tycoons and bureaucrats that skyscraping towers of burnished metal and glass provided a more fitting image of transparent honesty and soaring confidence. For a few decades we could catch glimpses of how the wheels of business and administration worked, or didn't work.

Quite recently a new phenomenon has begun to obscure that image. The latest towers are being sheathed not in transparent but in reflecting one-way mirrors. It is difficult to accept that the shift in style is merely practical or esthetic (although at least one major bank has had the reflective element in its headquarters windows tinted with pure gold). The innovation must surely be based on some fundamental shift in attitude or philosophy. Could it be that, at a time when business is subject to so much criticism and distrust, those inside want to scrutinize the world in secret? And that at the same time they wish the disgruntled man in the street, when he gazes at their institutions, to see only himself and his community reflected in them?

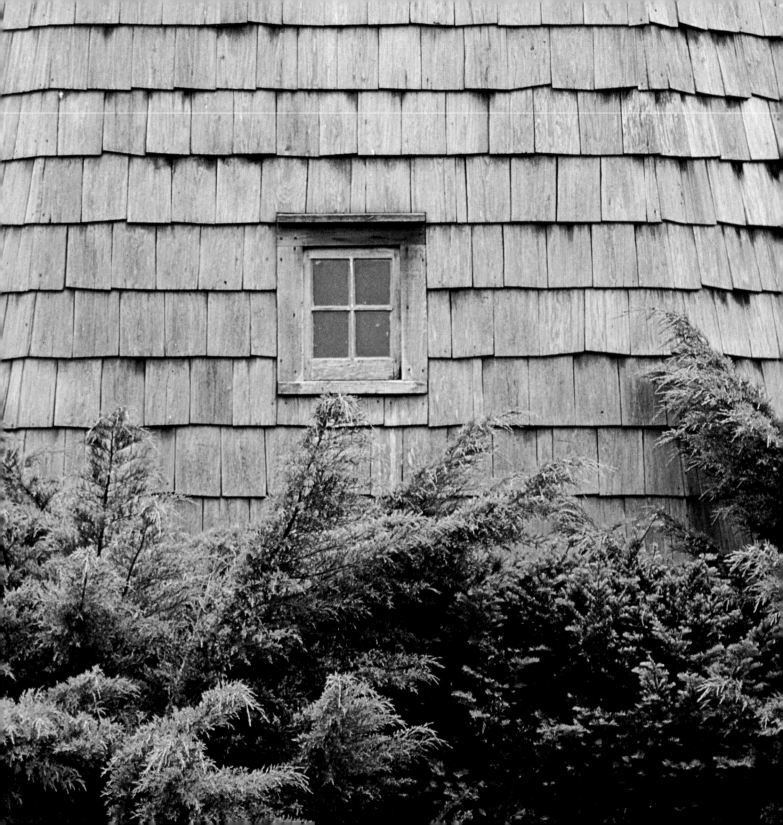

broken and neglected…

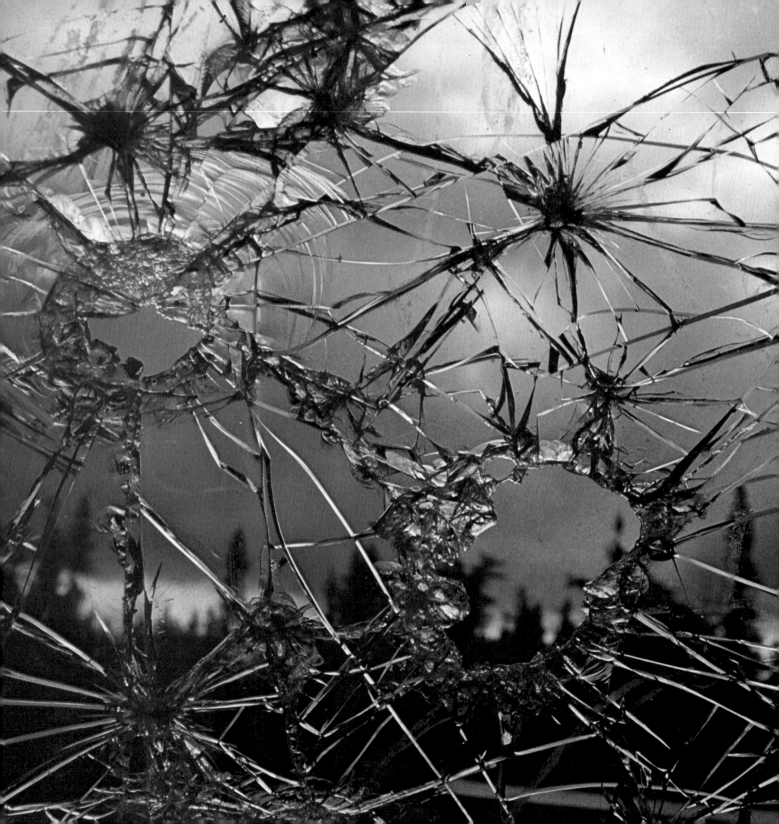

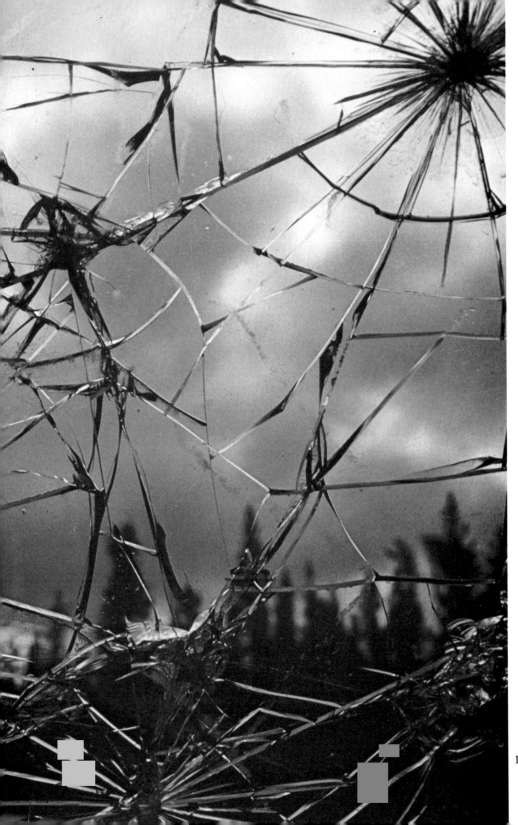

Is there something about the sight of a dirty neglected window that brings some basic human animosity to the boil? Or is it pity, are there a few sensitive souls who wander about putting uncared-for windows out of their agony? Or do neglected windows themselves break silently in the darkness, like languishing hearts? Certainly there always seem to be more broken windows about than can be blamed on boys wishing to prove their prowess with the slingshot.

108

107

The date most tragically associated with broken windows in all of human history is November 9, 1938. On the evening of that day, the Nazis unleashed their stormtroopers in a frenzy of violence against the Jewish community throughout the Third Reich. Defenseless Jews were beaten and imprisoned, their property looted or destroyed, and the glass from the windows of thousands of Jewish homes, synagogues and business premises was scattered about the streets. Thereafter that night was known as *Krystallnacht*. It was a prelude to more appalling horrors, culminating in Adolf Hitler's "Final Solution of the Jewish Problem." The unspeakable climax went virtually unnoticed, for when it occurred the windows of Europe were being shattered by a nightly rain of bombs.

"In the central slummy part of the town are the small workshops of the 'little bosses,' i.e. small employers who are making chiefly cutlery. I don't think I ever in my life saw so many broken windows. Some of these workshops have hardly a pane of glass in the windows and you would not believe they were inhabitable if you did not see the employees, mostly girls, at work inside."

from *Road to Wigan Pier* Diary by George Orwell

109

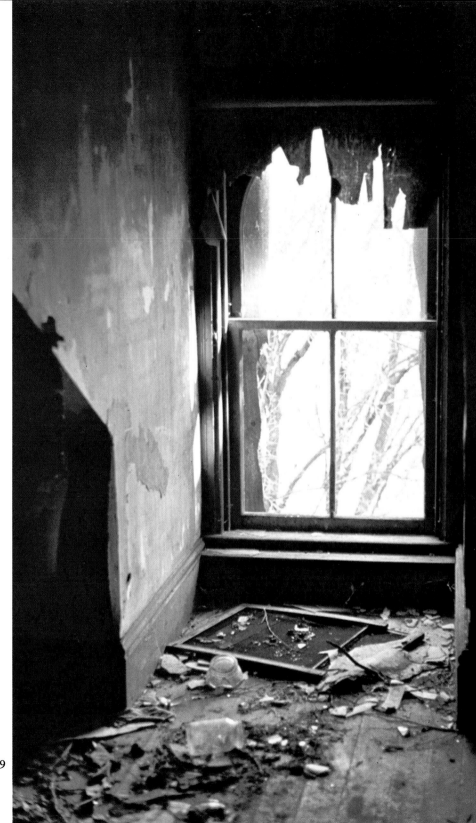

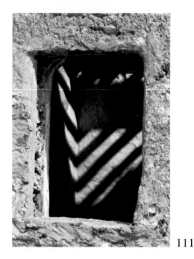

111

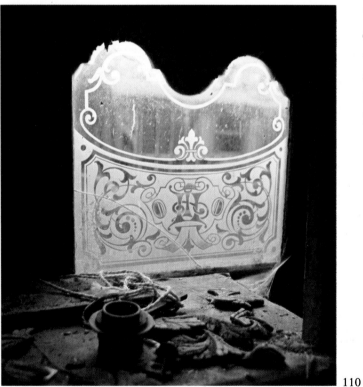

110

"I should like the window to open onto the Lake of Geneva —and there I'd sit and read all day like a picture of somebody reading."

John Keats in a letter to Fanny Keats

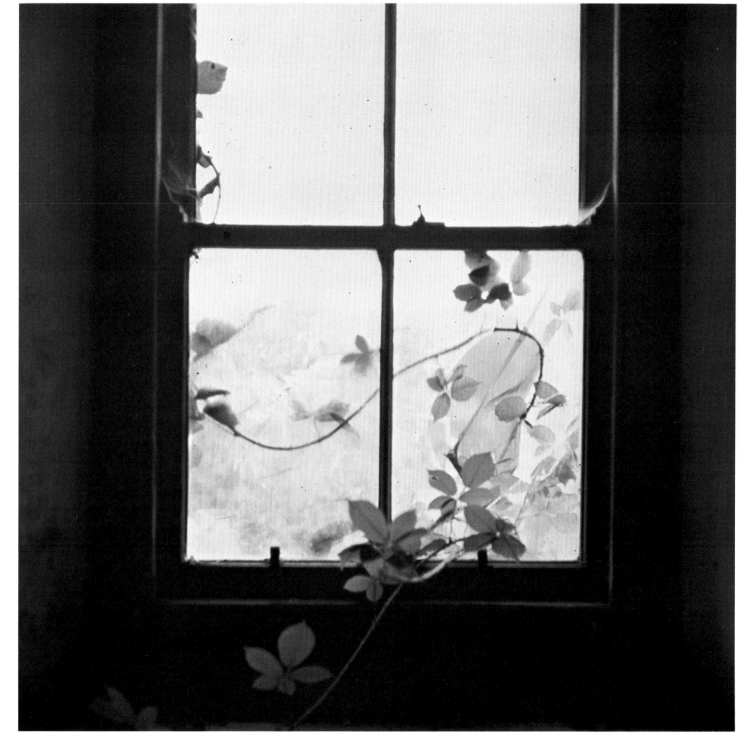

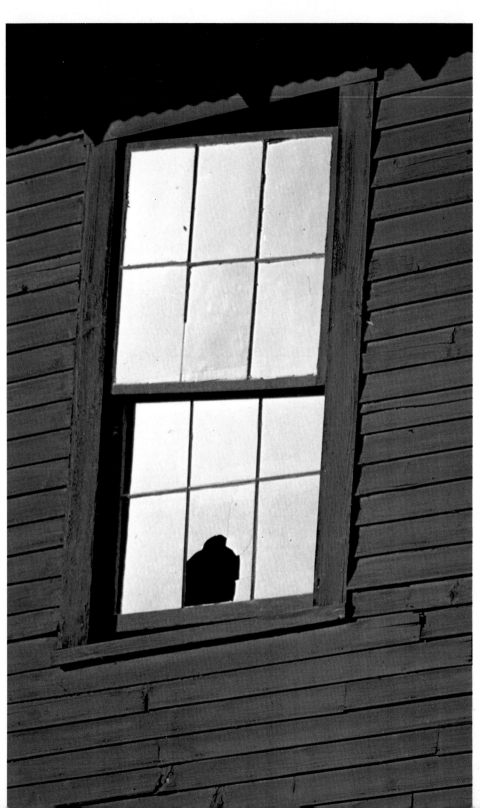

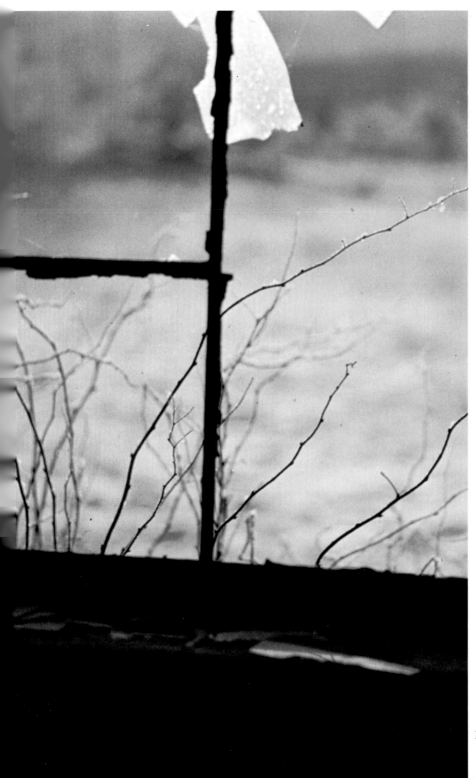

Factory windows are always broken,
Somebody's always throwing bricks,
Somebody's always heaving cinders,
Playing nasty Yahoo tricks . . .

Vachel Lindsay

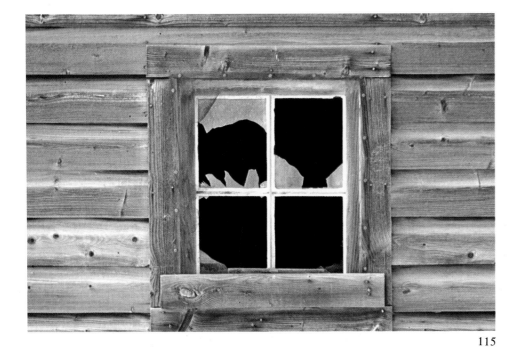

115

By long tradition, windows have always been among the first casualities in times of civic or industrial strife. It's doubtful if windows are broken by mobs or incensed individuals merely out of malice, or even because they are the property of a boss or a political enemy. It is more probable that bricks are hurled at windows for the same reason, at closer quarters, that fists are hurled first of all at eyes. Windows are the most vulnerable parts of a building, as eyes are the most vulnerable part of a man. And through both your enemy watches you and challenges you.

For ye'll ne'er mend your fortunes,
Nor help the just cause,
By breaking of windows,
Or breaking of laws.

Hannah More, 19th century evangelist

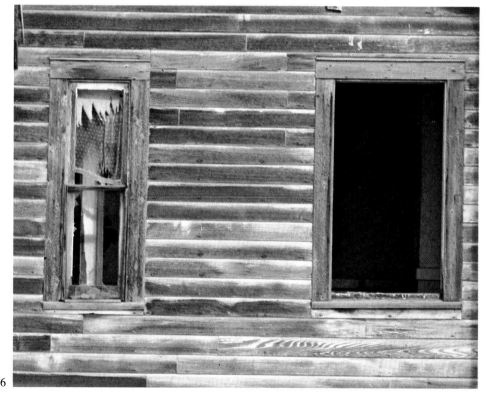

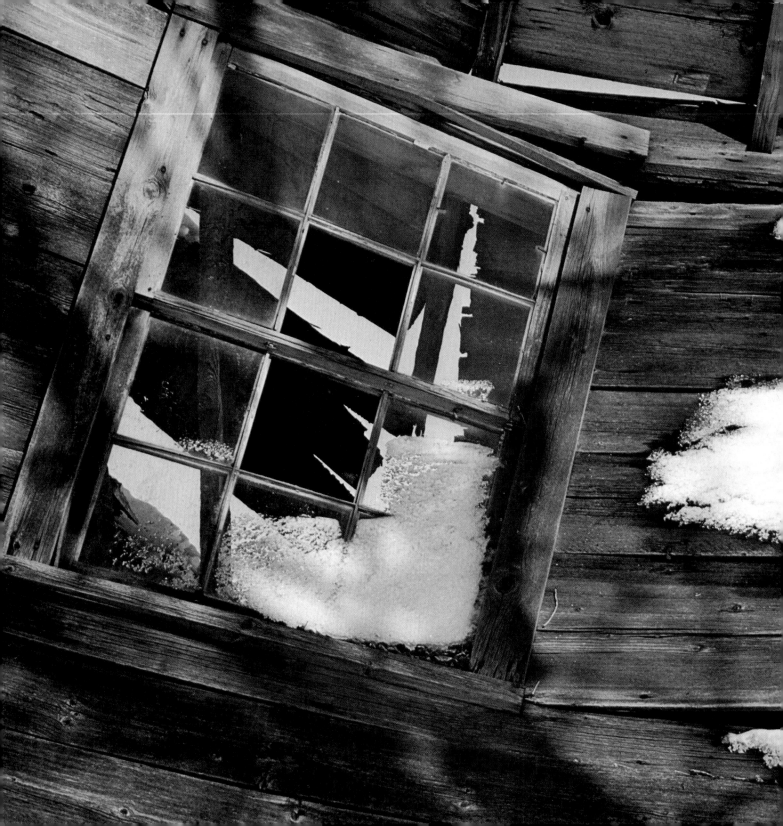

watchful eyes on a farmstead...

Unlike windows in town, farm windows are not generally expected to keep up appearances. In older farmhouses, they were not of the highest priority at time of building. For a family that would be spending much of the span from dawn to dusk working outside the home, only the kitchen window was a necessity, to light the work of the woman of the house. And glass, it must be remembered, unlike lumber and stone, was a material that had to be bought and carried from town.

There was no passing world to be watched, only the slow parade of weather and season and sense of that is for most farmers the sixth sense anyway.

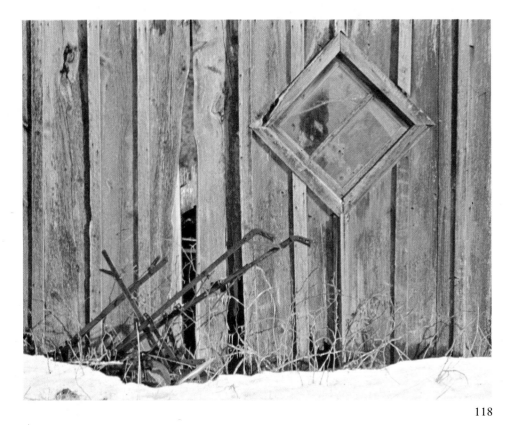

"The house was obviously makeshift, a homesteader's shack where the family might live until they had the money and leisure to build the kind of house the wife wanted. But the stable, even now, showed evidence of careful craftsmanship, as if the builder had tried to carve a symbol that would lend of its perfection to all his efforts —his flocks and his lands and his house. The walls still stood as straight and as firm as the day they were laid, but the door was gone from its hinges, and in the front, two square holes stood black and empty, with slivers of glass strewn on the ledge beneath them. The roof had never been finished, so the loft was open to the sky. Only the log that formed the roof beam had been placed, supported by gables at either end."

from *Goldenrod* by Herbert Harker

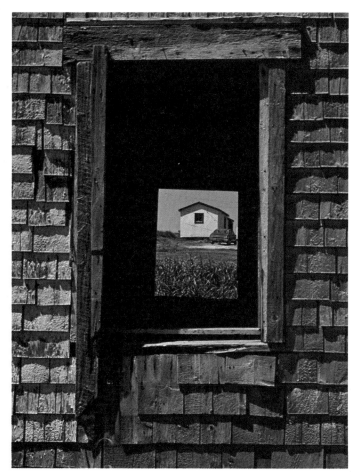

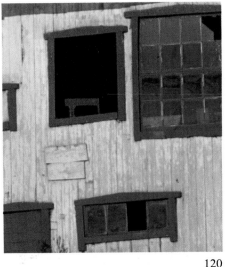

120

Farmsteads, like the earth on which they stand, tend to develop waywardly and gradually. A succession of good growing years may afford the margin of prosperity that will allow for wary extension, first of the outbuildings, then of the home. Windows tend to follow this fortuitous pattern of growth. The walls of barns, lofts, coops may be opened to light the work within and glazed the next year if prosperity persists. A window in a gable of the home may provide extra room also for growth of family.

Windows can chart the advance of fortune. But just as tellingly—cracked panes left unrepaired, frames unpainted, cracked and warped—they mark reverse and decline. And when a season turns against him, when crops lie ruined on his land, a farmer may wish his home had no windows to remind him of his helplessness. He will be the first to the window, of course, if a grumble of thunder hints the end of a drought, or a gleam of sunshine the breaking of an iron frost.

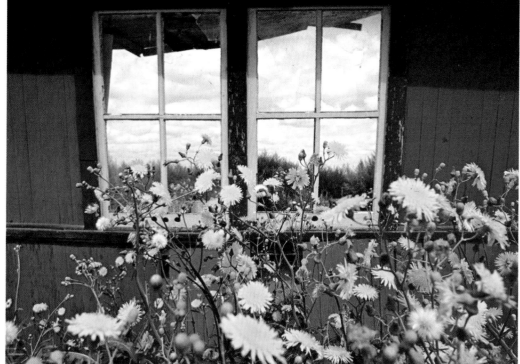

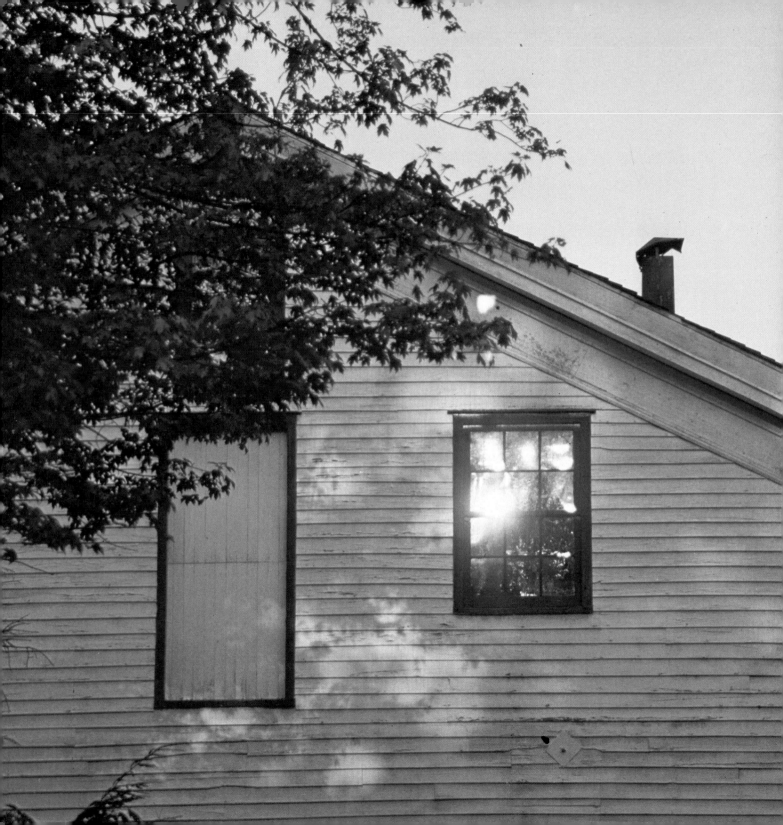

And not by eastern windows only,
 When daylight comes, comes in the light,
In front the sun climbs slow, how slowly,
 But westward, look, the land is bright!

Arthur Hugh Clough

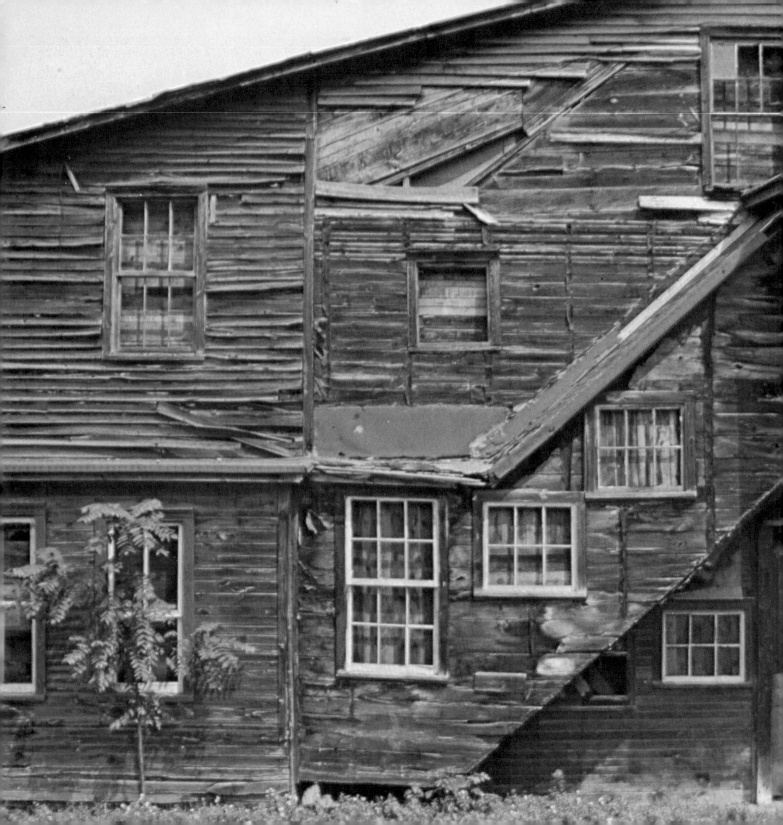

unveiling signs of imperfection...

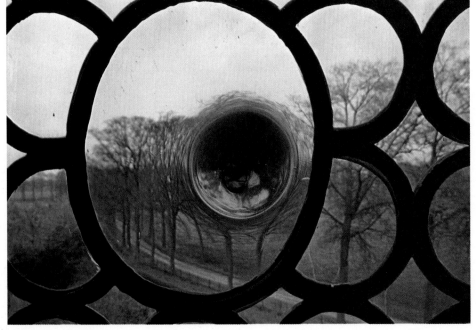

Clear unblemished plate glass rolls effortlessly on to the market nowadays from tanks of molten metal. The process is the ultimate triumph of thousands of years of glassmaking. So now collectors scour the antique stores for panes flawed by the technical shortcomings of the past. But even such anachronisms are not beyond the ingenuity of modern glassmakers. Imperfection brings its own rewards.

124

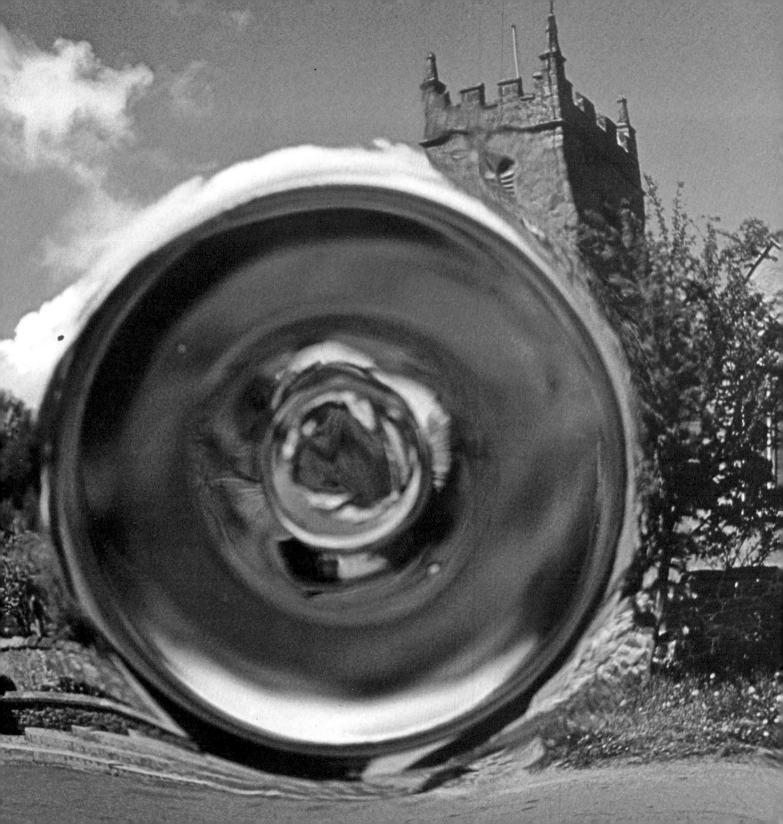

*displaying proof
of nature's
dread...*

126

127

In many of our larger cities we are virtually at the point where, if we should so choose, we could live from one year's end to the next without experiencing the outside climate for more than a few moments at a time. It's doubtful if many of us would choose to live entirely in a cocoon of conditioned air. After all the history of our species has conditioned us to surviving every element of this earth's climate. All of us have a deep-rooted fascination with the weather however little it affects our daily lives. A sweeping fall of snow, the melodramatics of a thunderstorm, will draw us all to the windowpanes and hold us there, mesmerized. Many of us in even a well-ventilated room feel an irresistible need to open a window, to run our fingertips across the icy surface of a frost-etched pane. . . . Is it to remind ourselves that we have it within us to survive?

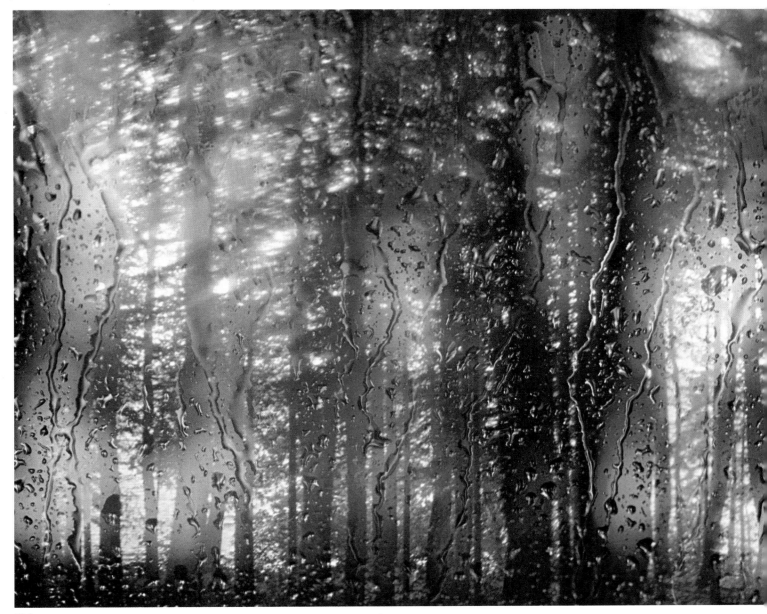

"I could hear the frost crackling outside. Greenish moonbeams shone through the windows covered with ice. . . . In the daytime I could hear ravens croaking, and on peaceful nights the mournful howling of the wolves reached the house from the fields. To this music my soul matured. Then, timidly and imperceptibly at first, but growing warmer every day, the shy face of spring peeped through the window with the radiant eye of a March sun. Cats began howling and singing on the roofs and the rustling sounds of spring penetrated the walls; icicles snapped, melted snow slid from the ridge of the roof, and the bells rang out more sonorously than they did in winter."

from *My Childhood* by Maxim Gorky (translated by Ronald Wilks)

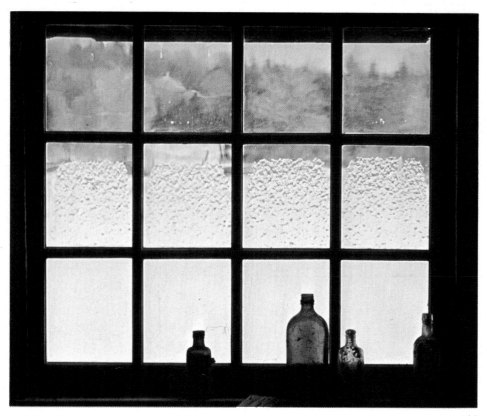

129

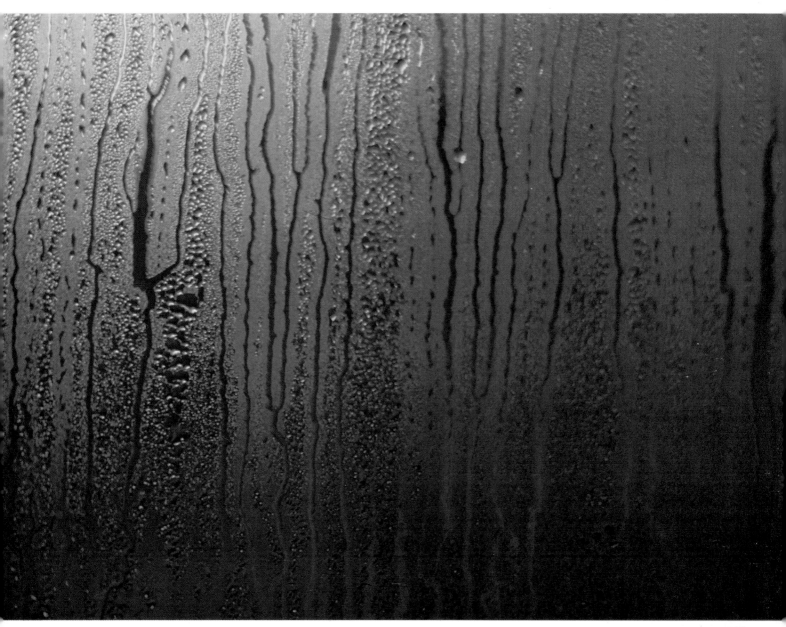

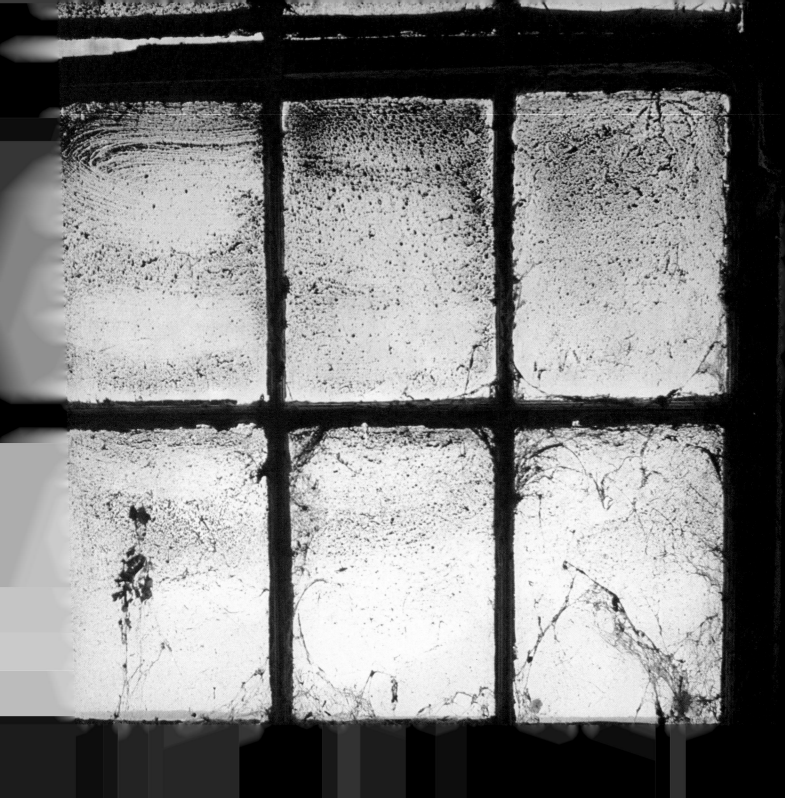

*Says the window
what heart
in this weather?*

George Johnston

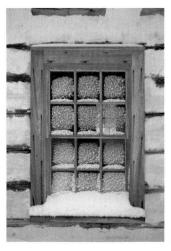

132

133

*Are you awake? Do you hear the rain?
How rushingly it strikes upon the ground,
And on the roof, and the wet window pane!
Sometimes I think it is a comfortable sound,
Making us feel how safe and snug we are. . . .*

Helen Hoyt

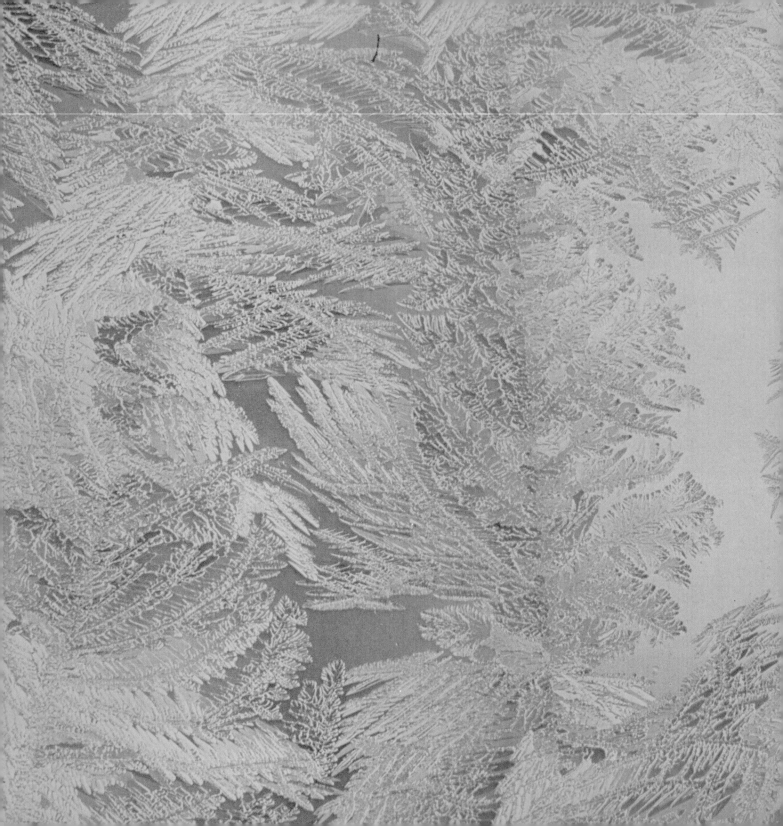

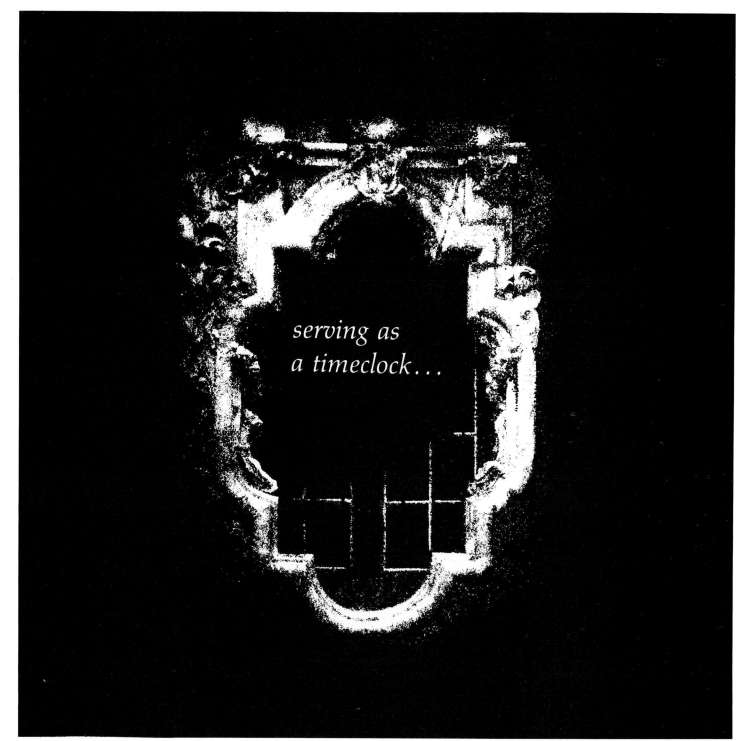

serving as
a timeclock...

Busy old fool, unruly Sun,
Why dost thou thus,
Through windows, and through curtains, call on us?
Must to thy motions lovers' seasons run?

John Donne

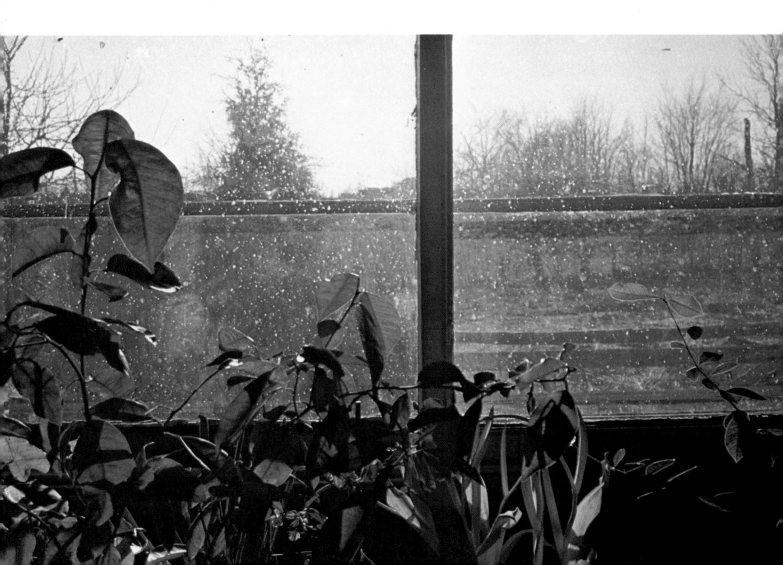

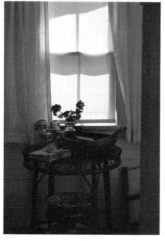
136

If we do curse windows occasionally for complicity in ending our lovemaking or our sleep, we should not fail to appreciate that they effect that end with a grace and gentleness that alarm clocks and human knuckles have yet to learn.

Windows are rivalled only by sundials as perfect self-effacing timekeepers. No nagging tick, no accusatory black hands to strain and confuse drowsy eyes. When we can discern a familiar distant spire outside, we know it is almost sunrise. When the first ray of sunshine warms our cheek, we know it is past time for breakfast. When the sun withdraws from our room and floodlights an adjoining wall, we can pleasurably infer that we have somehow dreamed the entire morning away.

Even illness or insomnia, intolerable behind closed curtains, can be made bearable by watching sunlight or moonlight work magical transformations upon a vista that we think we know in every detail. No wonder windowless cells are the favorite instruments of torturers and jailers.

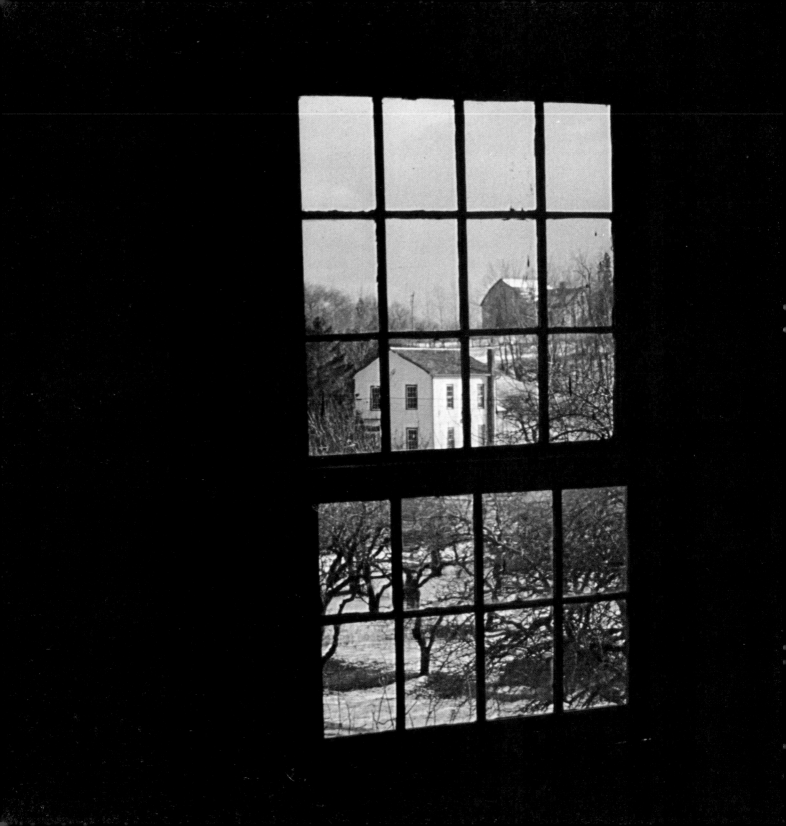

*sometimes
blocked and
sealed blind…*

137

138

There is something disquieting and profoundly depressing about windows boarded over or bricked up. Perhaps the implication of mortality, equivalent to the pennies that used to cover the eyes of corpses, since windows blocked in this way usually indicate that a building has been condemned and awaits only the last rites of the wrecker's hammer.

But in certain 18th century mansions still elegantly standing in England, you see tall window frames, usually in side walls, neatly filled with brick. These are memorials to the perpetually poverty-stricken George IV, who at one barren point in his reign was obliged to put a tax on windows. The affluent in those days were in no way less ingenious in avoiding taxes than their counterparts today, although they could hardly have called their stratagem a "loophole."

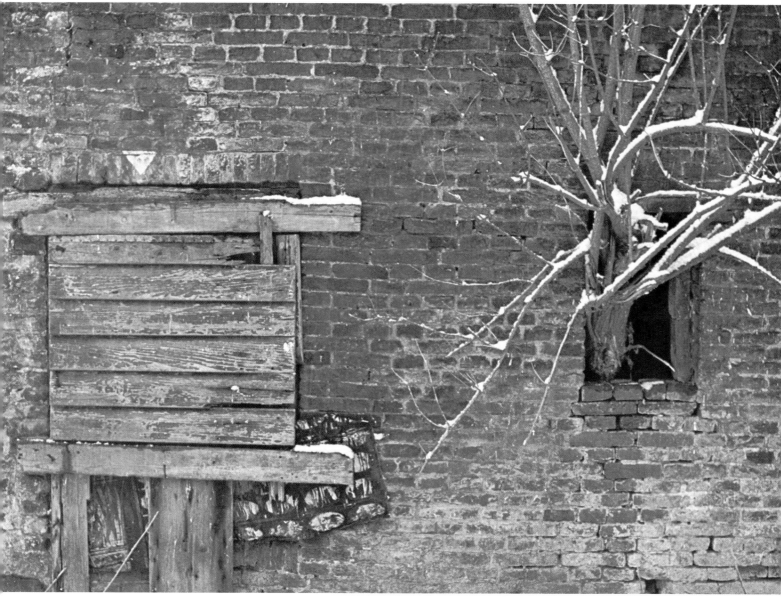

139

In certain parts of Europe you may also see what appears to be a window in the facade of a building but which, on closer scrutiny, turns out to be a stucco window frame enclosing a blank wall on which has been painted a *trompe l'oeil* window; an inexpensive means of adding to the dignity and symmetry of a dull house front. More recently, in the modish SoHo district of New York, artists have used the same means to transform the blank-faced warehouses in which they have their studios and galleries into many-windowed palaces of art. The clear northern light so sought after by artists in the past is, in the age of fluorescence and abstraction, no longer a necessity. Only the illusion that art is in touch with the outside world needs to be maintained.

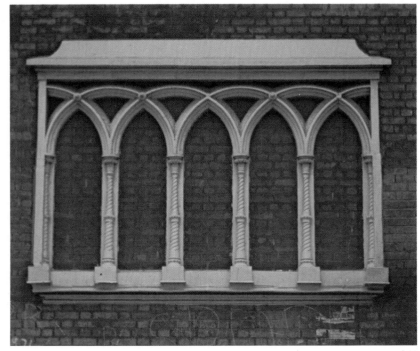

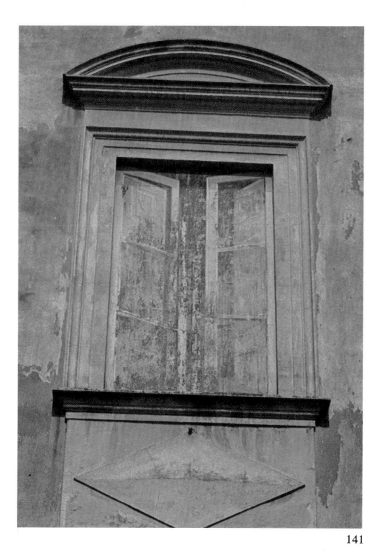

141

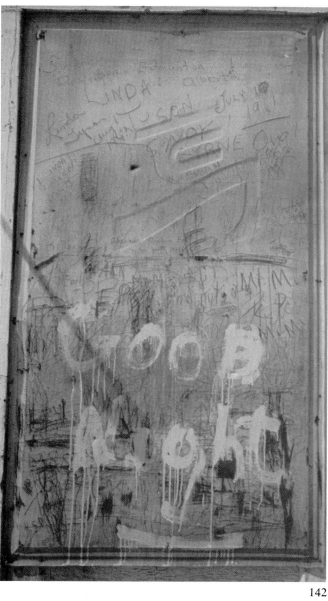

142

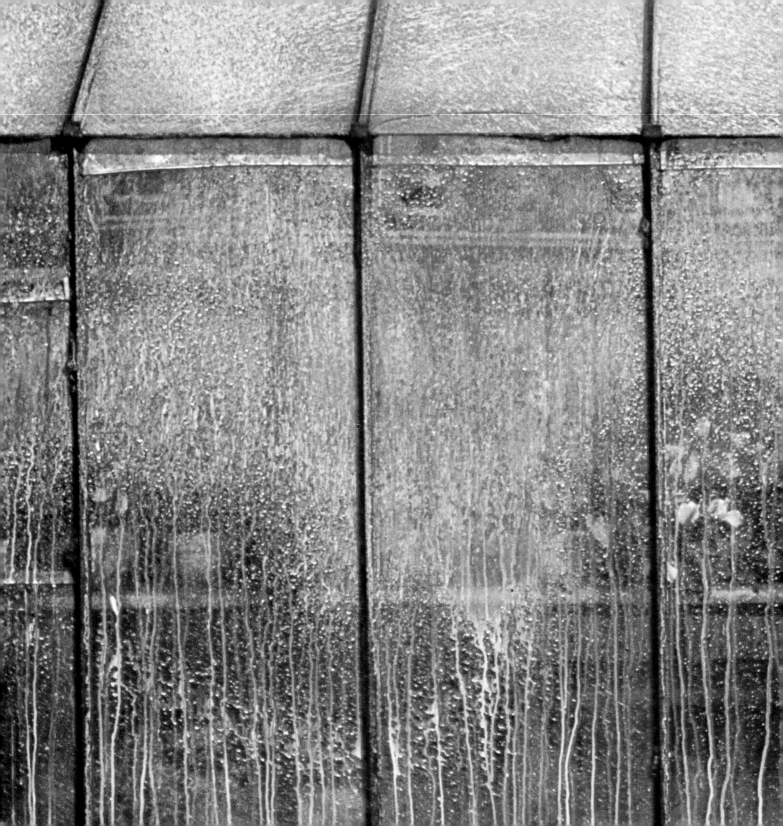

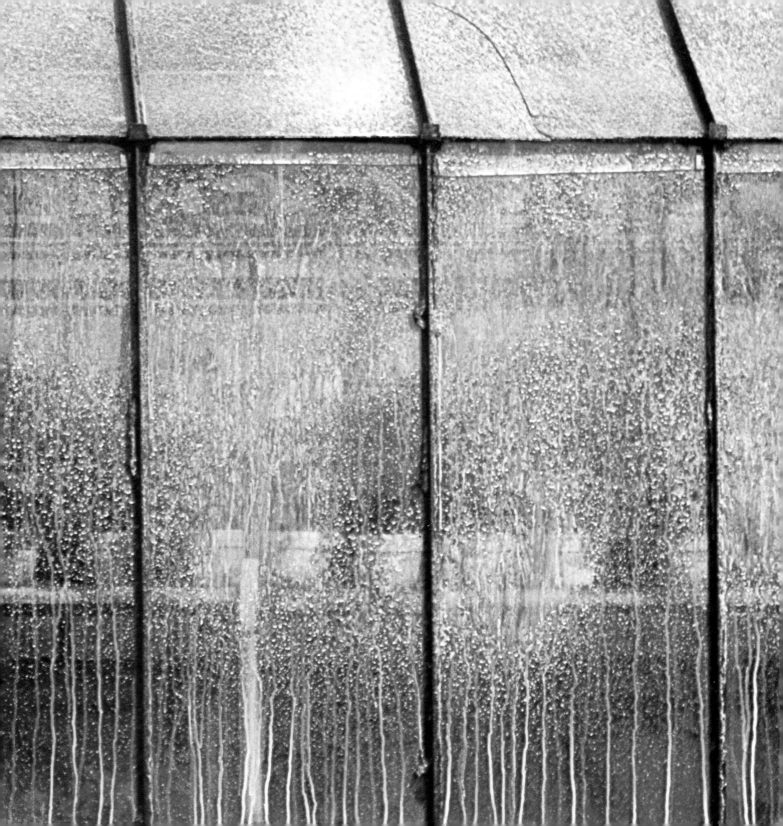

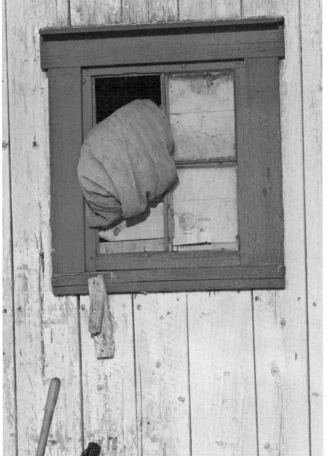

Unfortunately, windows are never short of enemies. If they are merely utilitarian, designed only to provide illumination rather than visual edification, they are always prey to progress. Electricity dimmed the prospects of millions of windows that had been serving a useful purpose in barns, warehouses, storerooms and workshops. If they were not abandoned to the obscure burial of grime or as targets of random human spite, they were painted over or adapted as loading bays, conduits for cables, or terminals for ventilation ducts. Even the most secure of windows, those in homes and apartments, are being demeaned and reduced these days to accommodate the air conditioning units that are usurping one of the primary roles of windows. But of course those who sit glassy eyed before television sets day after day are not concerned by the fact that they cannot gaze out through air conditioners.

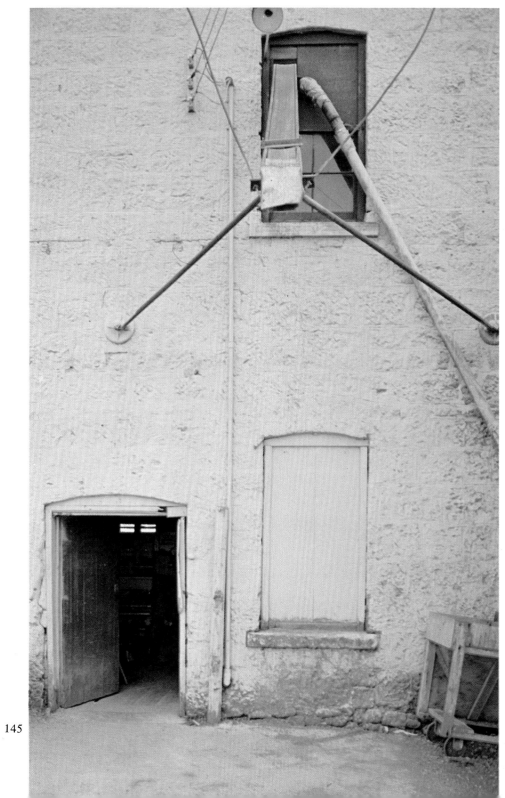

145

Shutters are partly a relic of the times when it might be safe enough to leave windows open by day but to do so at night was to invite footpads and thieves into your home. Even when the rule of law had gained the upper hand, shutters were retained for their secondary purposes: in northern climates solid shutters helped to insulate homes from the biting cold of winter; in southern countries louvred shutters eased the siesta by shutting out the blaze of the sun while allowing the breezes to flow in.

Although shutters have followed the flag of various migrants to North, Central and South America, their future is threatened already by central heating, double glazing and air conditioning; soon they will survive only as window dressing.

"Tell a fool to close the shutters," says a Yiddish proberb, "and he'll close all the shutters in town." Shutters in their heyday may have been an impediment to window gazers but, like sunglasses over eyes, only a temporary impediment. Their obsolescence can only be good.

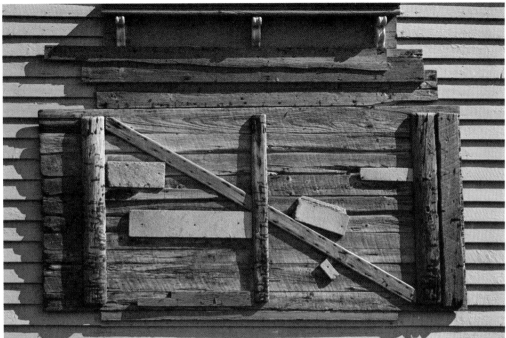

146

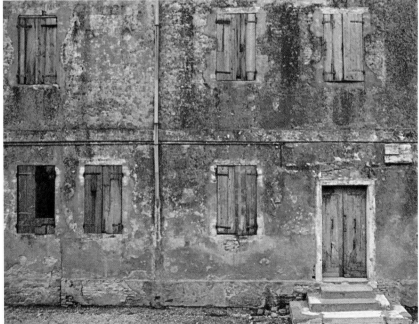

147

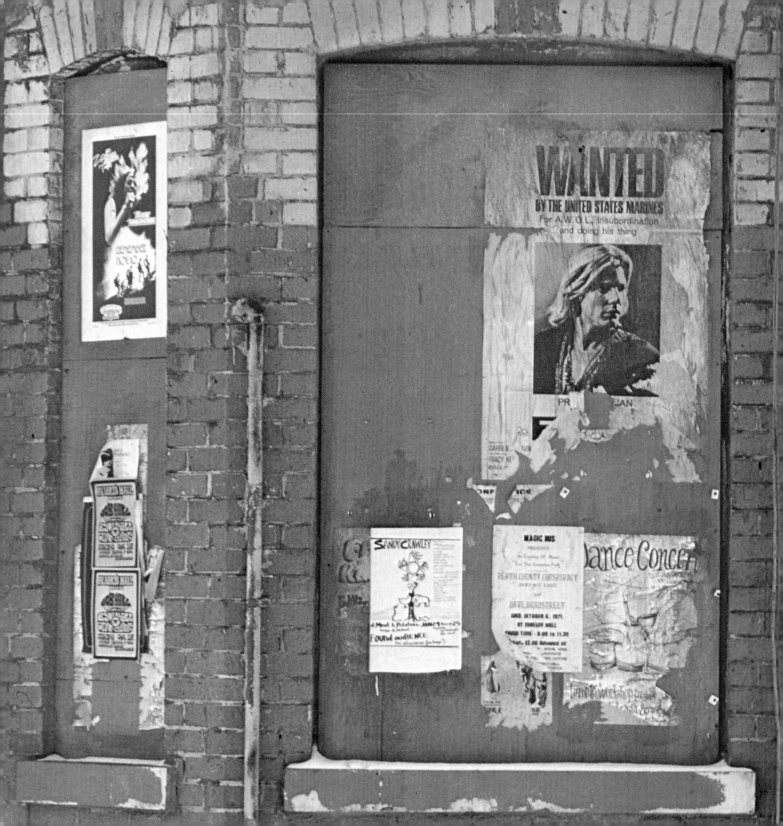

*And as art
seeks its
perfection...*

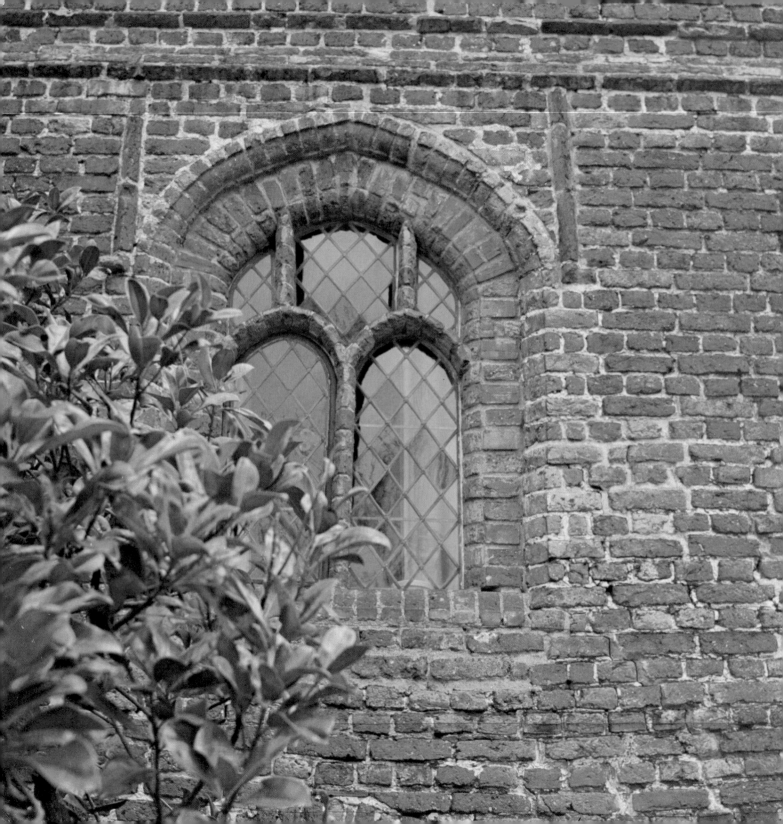

Art most often seems to approach perfection under the discipline of limitations. It is ironic that the early problems of glassmakers in producing sheet glass should have dictated the development of leaded glass panes, and that this should have engendered in turn not only the dazzling beauty of stained glass windows but the entrancing intricate tracery which nameless craftsmen wove from the mullions and transoms needed to brace the windows and from the arches needed to install windows.

150

149

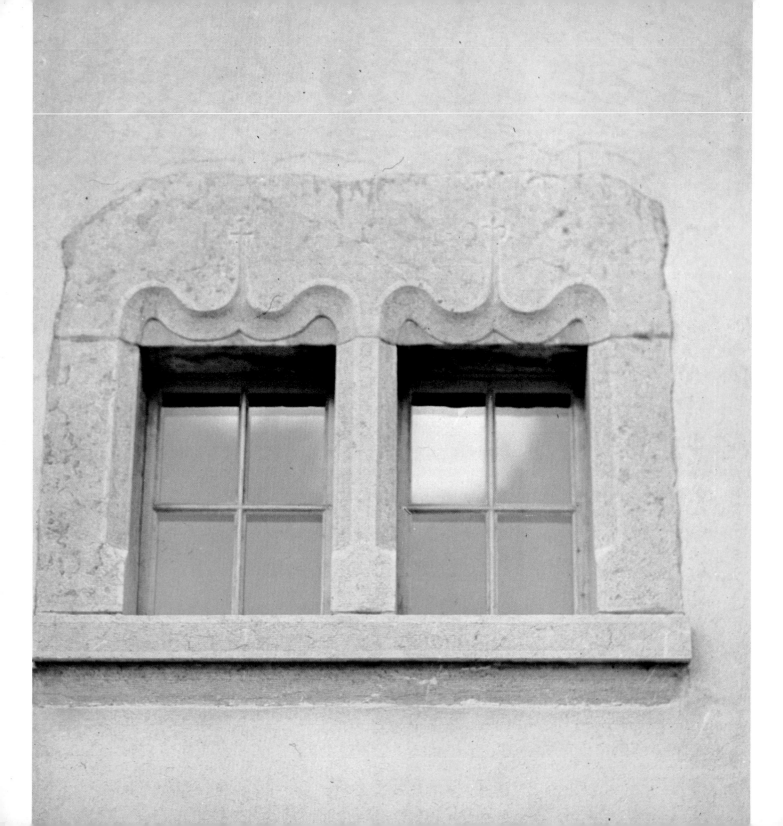

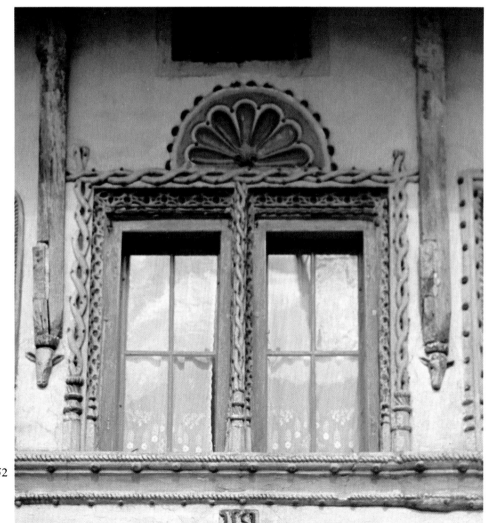

151

152

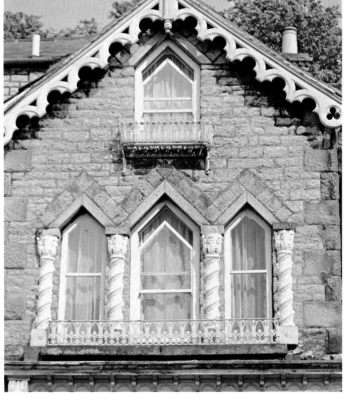

153

It is ironic because nowadays, when glassmaking knows no limitations, older buildings graced by windows in the finest tradition of the past are being torn down to make room for glass towers with no virtue other than size. And because in many older houses fine casements and beautifully crafted sashes are being destroyed to make room for the modish blandness of picture windows. We will realize when we can no longer replace what we have destroyed that glass is only a part of a window and that the whole is incomparably greater than its parts.

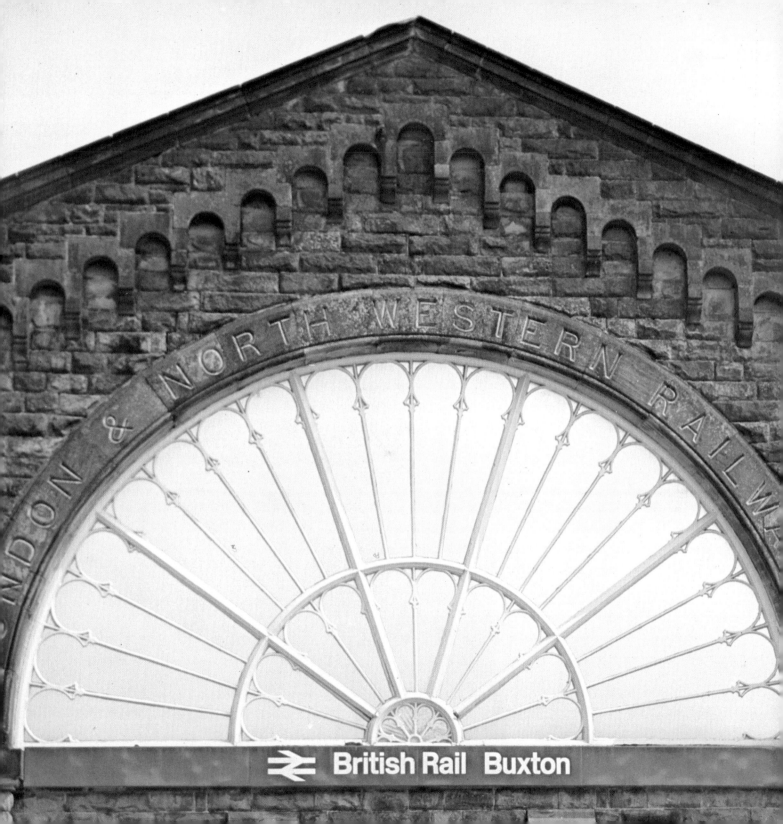

We have arrived at a point in the developed world where massive population, the by-product of our success in surviving, presents us with problems that dictate massive solutions. We have to accept the fact that many of our necessities must be mass-produced. Only a few of us, for instance, have the means and opportunity to live in houses that were created with care and craftsmanship for individuals who valued such qualities. But at least, in gazing out through our mass-produced efficient windows, we should be entitled to see preserved some traces of a past that could value quality above quantity, some buildings of grace and distinction, with windows that will tell us how we came to where we are today: because if we do not understand how we came here, we will never understand why we are here, or even where we are.

As humans we have always known how to fight for our future; we must learn at once how to fight for our past.

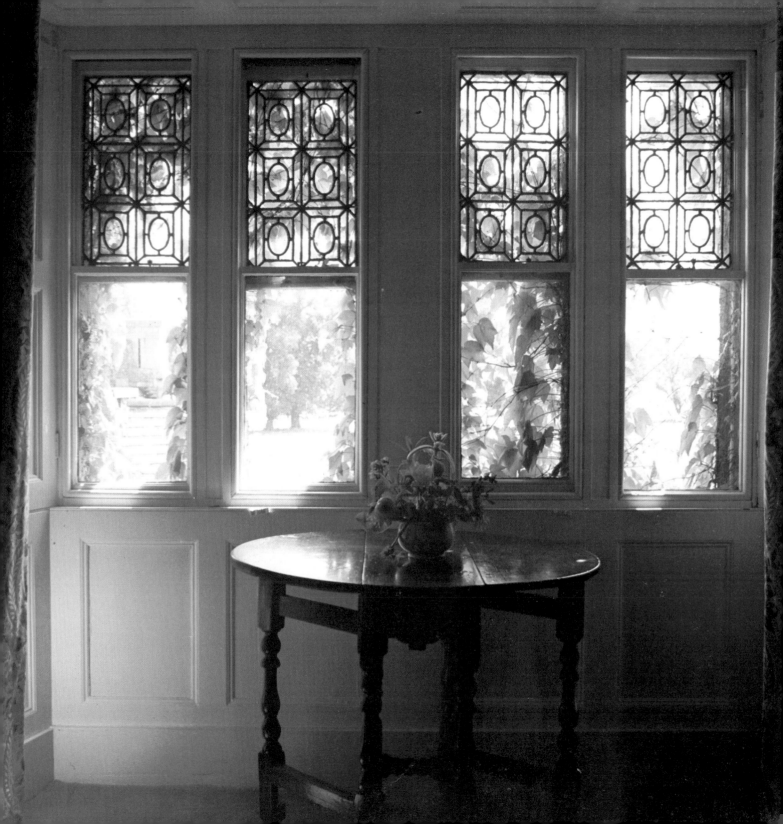

Photographs

Photographers

ACKNOWLEDGEMENTS

Ascension by Denis Devlin. Reprinted
with permission of The Dolmen Press.
Copyright The Dolmen Press. *Factory
Windows are Always Broken* by Vachel
Lindsay. Reprinted with permission of
Macmillan Publishing Co. Inc. from
Collected Poems by Vachel Lindsay.
Copyright 1914 by Macmillan Publishing
Co. Inc. renewed 1942 by Elizabeth C.
Lindsay. *Goldenrod* by Herbert Harker,
Reprinted with permission of Random
House Inc. Copyright Herbert Harker
1973. *The Collected Essays, Journalism
and Letters of George Orwell.* Reprinted
with permission of A.M. Heath & Co. Ltd.
Copyright Sonia Brownwell Orwell 1945,
1952, 1953 and 1968. *My Childhood* by
Maxim Gorky, translated by Ronald
Wilks. Copyright Ronald Wilks 1966,
Penguin Books Classics 1966. Reprinted
with permission of Penguin Books Ltd.
*The Unquiet Grave: The Tomb of
Palinarus* by Cyril Connolly. Copyright
1945 by Cyril Connolly. Reprinted with
permission of Harper & Row Publishers
Inc., and Hamish Hamilton Ltd., London.
The View from an Attic Window
by Howard Nemerov. Published by
Routledge & Kegan Paul, London 1947 in
*A Little Treasury of Modern Poetry —
English and American,* edited by Oscar
Williams. *Rain at Night* by Helen Hoyt.
Published by Routledge & Kegan Paul
1947 in *A Little Treasury of Modern
Poetry — English and American,* edited
by Oscar Williams. *Tree at my Window* by
Robert Frost, published by Holt,
Rinehart & Winston. The Publisher has
made every effort to trace copyright
ownership of all material quoted in this
volume and apologises if anything has
been used herein without proper acknow-
ledgement and permission. In any such
event, the proper credit will be included in
the next printing of the book.

Val Clery was born and grew up in Dublin. Following wartime service as a commando, he worked as a writer and broadcaster in Ireland, in Britain and in Canada, where he now lives. He was founding editor of the periodical *Books in Canada* and has written for Canada's leading newspapers and magazines. His other books include an anthology of Canadian non-fiction and *Doors,* the companion volume to *Windows*.